The Fundamentals of DRAWING STILL LIFE

The Fundamentals of DRAWING STILL LIFE

A PRACTICAL AND INSPIRATIONAL COURSE

Barrington Barber

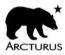

This edition published in 2008 by Arcturus Publishing Limited 26/27 Bickels Yard, 151–153 Bermondsey Street, London SE1 3HA

Copyright © 2004 Arcturus Publishing Limited

All rights reserved. No part of this publication may be reproduced, stored in a retrieval system, or transmitted, in any form or by any means, electronic, mechanical, photocopying, recording or otherwise, without written permission in accordance with the provisions of the Copyright Act 1956 (as amended). Any person or persons who do any unauthorised act in relation to this publication may be liable to criminal prosecution and civil claims for damages.

ISBN: 978-1-84193-321-4

Printed in Singapore

Contents

Introduction	6
First Steps	8
Exploring Textures	40
Combining Objects	60
Themes and Composition	82
Expanding the View	110
Varying Techniques and Materials	124
Playing with Still Life	144
Unusual Arrangements	156
Bringing It All Together	180
Index	208

Introduction

TILL LIFE IS A VERY WELL-PRACTISED AREA of drawing and painting and has been the route by which many artists have learnt about techniques and style. This is because it is the most easily available of art's themes and doesn't require a model or a fine day. The artist has only to look around his home to find all he needs for an enjoyable drawing session to keep his hand and eye in.

Perhaps because of its comparatively small scale or domestic nature, it has taken time for still life to be appreciated, and from about 1600 onwards until the 20th century it sat firmly at the bottom of the ladder in the hierarchy of artistic themes. Then still life, or *nature morte*, as the French call it, began to be recognized as having just as much significance in the art of drawing and painting as portraiture, history painting, figure painting, or landscape.

It began to be seen that a brilliant Chardin still life was as good if not better than any painting by a lesser artist, however elevated the theme.

In one sense it is an easy option: all of it can be produced in the studio and it has none of the problems associated with other types of art. Unlike people, the objects of a still life don't move and they don't need rests. As a subject for novice artists still life is ideal because any objects can be used and you can take all the time you need in order to draw them correctly.

Drawing still life opens your eyes to the possibilities of quite ordinary items becoming part of a piece of art. Around any house there are simple everyday groups of objects that can be used to produce very interesting compositions. If you follow my suggestions you will quickly

learn how to choose objects and put them together in ways that exploit their shape, contrasting tones and sizes, and also the materials that they are made of.

I have not assumed that all readers of this book will come to it with a great deal of experience of drawing, and so we start at a very basic level. The exercises set out are intended to ease into the subject someone who has never really drawn before, yet also provide useful refreshers for those of you who are already practised in drawing. Primarily we deal first with drawing objects, building up from simple shapes to complex, before moving on to tackle the drawing of still-life arrangements.

With these too we start very simply and gradually bring in more and more objects to create themes; you will have no shortage of themes to choose from. Conversely, you will also discover that arrangements involving few objects can be as, if not more, effective. Some of the most famous still-life artists have restricted their arrangements quite drastically and still become masters of the genre.

I do hope you enjoy exploring this area of drawing with me, and that by the end of the book you will be looking at the objects around you with a keen awareness of the possibilities they offer you for self-expression.

Barrington Barber

Wimbledon, March 2004

First Steps

HE FIRST STEPS IN ANY ART are always at one and the same time the most exciting and the most daunting. However, as long as the desire to accomplish some practice in the particular form of expertise is there, this should ensure that the enterprise is ultimately successful.

You will find in this first section of the book a range of different exercises, beginning with the extremely basic. The aim is to prepare you for drawing actual still-life compositions. Before the composing of any picture can be effective, the artist needs to work hard to ensure that the quality of his drawing has reached the point where he can concentrate on the design

of the picture and not be concerned about the details of drawing the objects within it.

Looking carefully at each object before you start to draw it is a very good routine to adopt. This helps you to assess proportion, shape and position all at once, which in turn helps to inform your eventual drawing and composition.

In fact, as a regular practice, it is a good idea to first make separate drawings of the objects that will be in the composition so that you get the feel and experience of each one. Experience of drawing the object is knowledge made real. Without the experience it is just information.

Allied to this you need to give yourself plenty of practice in making careful drawings from observation. This involves correcting mistakes, leaving out parts that don't work and measuring and redrawing until the object being formed on your paper begins to resemble what you actually see, at least in shape and tone. The process outlined here and adopted in the following pages is slow and painstaking. If adopted it is the foundation for a really impressive drawing procedure, which should soon produce an improvement in technique.

Although this may seem like a hard slog, in fact it is just the regular drawing practice that any artist who wants to develop needs to do. It has always been considered a matter of course that you need to draw every day if you are to improve your skill, so look on this preliminary drawing as part of your normal method of teaching yourself to draw.

In this section you will find many exercises to help get you started on this activity. If you persevere, you will find that whatever your level of talent, it will be enormously improved by this process of steady observational drawing and practice of technical dexterity.

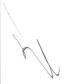

DRAWING MATERIALS

Any medium is valid for drawing still lifes. That said, some media are more valid than others in particular circumstances, and in the main their suitability depends on what you are trying to achieve. Try to equip yourself with the best materials you can afford; quality does make a difference. You don't need to buy all the items listed below, and it is probably wise to experiment gradually as you gain in confidence.

Start with the range of pencils suggested, and when you feel you would like to try something different, then do so. Be aware that each material has its own identity, and you have to become acquainted with its individual facets before you can get the best out of it or, indeed, discover whether it is the right material for your purposes. So, don't be too ambitious to begin with, and when you do decide to experiment, persevere.

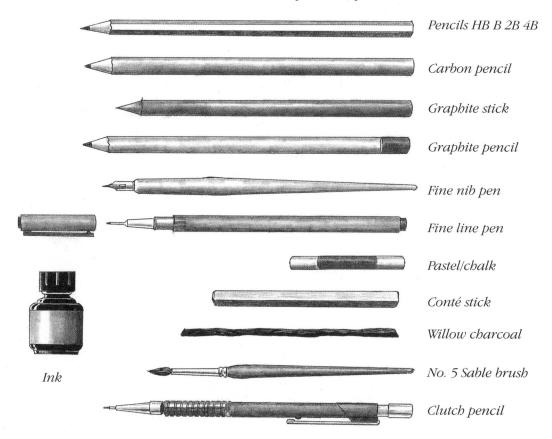

Pencil

The normal type of wooden-cased drawing pencil is, of course, the most versatile instrument at your disposal. You will find the soft black pencils are best. Mostly I use B, 2B, 4B and 6B. Very soft pencils (7B–9B) can be useful sometimes and harder ones (H) very occasionally. Propelling or clutch pencils are very popular, although if you choose this type you will need to buy a selection of soft, black leads with which to replenish them.

Conté

Similar to compressed charcoal, conté crayon comes in different colours, different forms (stick or encased in wood like a pencil) and in grades from soft to hard. Like charcoal, it smudges easily but is much stronger in its effect and more difficult to remove.

Carbon pencil

This can give a very attractive, slightly unusual result, especially the dark brown or sepia, and the

terracotta or sanguine versions. The black version is almost the same in appearance as charcoal, but doesn't offer the same rubbing-out facility. If you are using this type, start off very lightly because you will not easily be able to erase your strokes.

Graphite

Graphite pencils are thicker than ordinary pencils and come in an ordinary wooden casing or as solid graphite sticks with a thin plastic covering. The graphite in the plastic coating is thicker, more solid and lasts longer, but the wooden casing probably feels better. The solid stick is very versatile because of the breadth of the drawing edge, enabling you to draw a line 6 mm (1/4 in) thick, or even thicker, and also very fine lines. Graphite also comes in various grades, from hard to very soft and black.

Pens

Push-pens or dip-pens come with a fine pointed nib, either stiff or flexible, depending on what you wish to achieve. Modern fine-pointed graphic pens are easier to use and less messy but not as versatile, producing a line of unvarying thickness. Try both types.

The ink for dip-pens is black Indian ink or drawing ink; this can be permanent or water-soluble. The latter allows greater subtlety of tone.

Pastel/chalk

If you want to introduce colour into your still-life drawing, either of these can be used. Dark colours give better tonal variation. Avoid bright, light colours. Your choice of paper is essential to a good outcome with these materials. Don't use a paper that is too smooth, otherwise the deposit of pastel or chalk will not adhere to the paper properly. A tinted paper can be ideal, because it enables you to use light and dark tones to bring an extra dimension to your drawing.

Charcoal

In stick form this medium is very useful for large drawings, because the long edge can be used as well as the point. Charcoal pencils (available in black, grey and white) are not as messy to use as the sticks but are less versatile. If charcoal drawings are to be kept in good condition the charcoal must be fixed with a spray-on fixative to stop it smudging.

Brush

Drawing with a brush will give a greater variety of tonal possibilities to your drawing. A fine tip is not

easy to use initially, and you will need to practise if you are to get a good result with it. Use a soluble ink, which will give you a range of attractive tones.

A number 0 or number 2 nylon brush is satisfactory for drawing. For applying washes of tone, a number 6 or number 10 brush in sablette, sable or any other material capable of producing a good point is recommended.

Stump

A stump is a tightly concentrated roll of absorbent paper formed into a fat pencil-like shape. Artists use it to smudge pencil, pastel or charcoal and thus smooth out shading they have applied, and graduate it more finely.

Paper

You will find a good-quality cartridge paper most useful, but choose one that is not too smooth; 160gsm weight is about right. (If you are unsure, ask in your local art shop, where they will stock all the materials you require.)

Drawing in ink can be done on smoother paper, but even here a textured paper can give a livelier result in the drawing. For drawing with a brush, you will need a paper that will not buckle when wet, such as watercolour paper. Also see under Pastel/chalk.

Eraser

The best all-purpose eraser for the artist is a putty eraser. Kneadable, it can be formed into a point or edge to rub out all forms of pencil. Unlike the conventional eraser it does not leave small deposits on the paper. However, a standard soft eraser is quite useful as well, because you can work over marks with it more vigorously than you can with a putty eraser.

Most artists try to use an eraser as little as possible, and in fact it only really comes into its own when you are drawing for publication, which requires that you get rid of superfluous lines. Normally you can safely ignore erasers in the knowledge that inaccurate lines will be drawn over and thus passed over by the eye which will see and follow the corrected lines.

Sharpener

A craft knife is more flexible than an all-purpose sharpener and will be able to cope with any medium. It goes without saying that you should use such an implement with care and not leave the blade exposed where it may cause harm or damage.

LINES INTO SHAPES

Before you begin any kind of drawing, it is necessary to practise the basics. This is essential for the complete beginner, and even for the experienced artist it is very useful. If you are to draw well you must be in control of the connection between eye and hand. There are many exercises to help you achieve this.

The following are the simplest and most helpful I know.

Complete them all as carefully as you can, drawing freehand, at the sizes shown. The more you repeat them, the more competent and confident you will become – and this will show in your drawing.

Lines

As you draw, try to keep your attention exactly on the point where the pencil touches the paper. This will help to keep mind and hand synchronized and in time make drawing easier.

1. Begin with vertical lines, keeping them straight and the same length.

2. Produce a square with a series of evenly spaced horizontal lines.

3. Now try diagonal lines, from top right to bottom left, varying the lengths while keeping the spacing consistent.

4. Next, draw diagonals from top left to bottom right. You may find the change of angle strange at first.

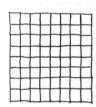

5. To complete the sequence, try a square made up of horizontals and verticals crossing each other.

Circles

At first it is difficult to draw a circle accurately. For this exercise I want you to draw a series of them next to each other, all the same size. Persist until the circles on the paper in front of

you look like the perfect ones you can see in your mind's eye. When you achieve this, you will know that your eye and mind are coordinating.

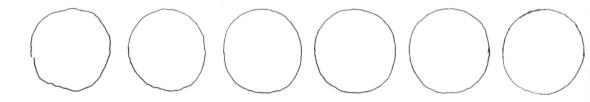

Variations

Paul Klee described drawing as 'taking a line for a walk'. Try drawing a few different geometric figures:

1. Triangle – three sides of the same length.

2. Square – four sides of the same length.

3. Star – one continuous line.

4. Spiral – a series of decreasing circles ending in the centre.

5. Asterisk – 16 arms of the same length radiating from a small black point.

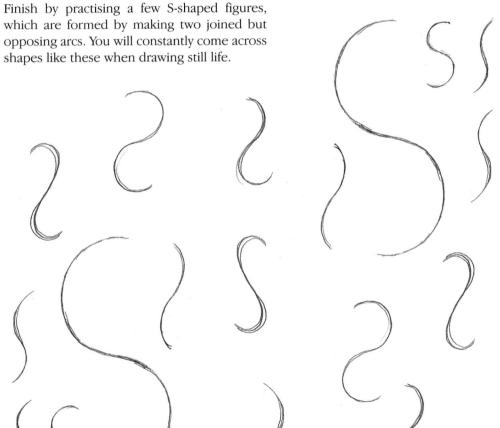

THREE DIMENSIONS

Every object you draw will have to appear to be three-dimensional if it is to convince the viewer. The next series of practice exercises

has been designed to show you how this is done. We begin with cubes and spheres.

1. Draw a square.

2. Draw lines that are parallel from each of the top corners and the bottom right corner.

3. Join these lines to complete the cube.

This alternative method produces a cube shape that looks as though it is being viewed from one corner.

1. Draw a diamond shape or parallelogram elongated across the borizontal diagonal.

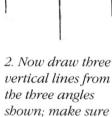

they are parallel.

3. Join these vertical lines.

Shading

Once you have formed the cube you are halfway towards producing a realistic three-

dimensional image. The addition of tone, or shading, will complete the trick.

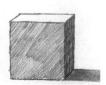

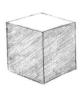

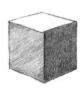

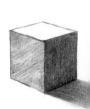

There is only one way of drawing a sphere. What makes each one individual is how you apply tone. In this example we are trying to

capture the effect of light shining on the sphere from top left.

1. Draw a circle as accurately as possible.

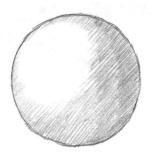

2. Shade in a layer of tone around the lower and right-hand side in an almost crescent shape, leaving the rest of the surface untouched.

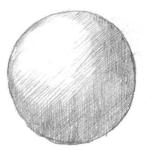

3. Subtly increase the depth of the tone in much of the area already covered without making it uniform all over.

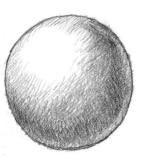

4. Add a new crescent of darkish tone, slightly away from the lower and right-hand edges; ensure this is not too broad.

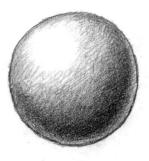

5. Increase the depth of tone in the darkest area.

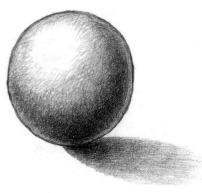

6. Draw in a shadow to extend from the lower edge on the right side.

ELLIPSES

One shape you need to learn to draw if you are to show a circular object seen from an oblique view is an ellipse. This is a curved figure with a uniform circumference and a horizontal axis longer than the perpendicular axis.

An ellipse changes as our view of it shifts. Look at the next series of drawings and you will see how the perspective of the glass changes as its position alters in relation to your eye-level.

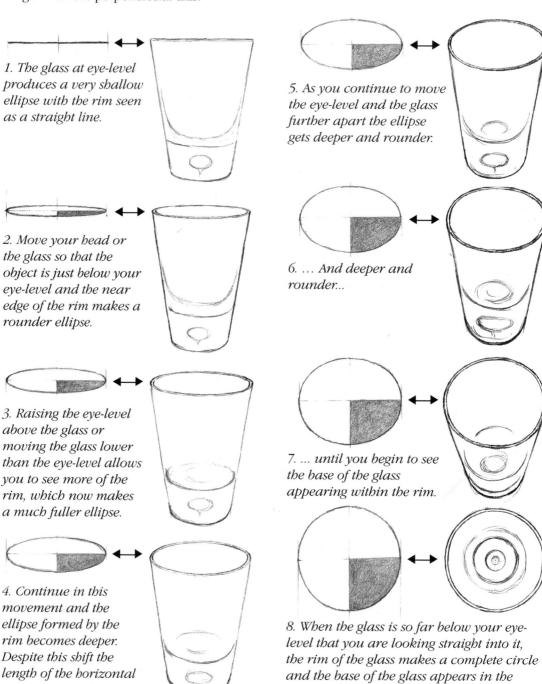

centre of the circular rim.

axis does not alter.

ELLIPSES PRACTICE: CYLINDERS

Ellipses come into their own when we have to draw cylindrical objects. As with our previous examples of making shapes appear threedimensional, the addition of tone completes the transformation.

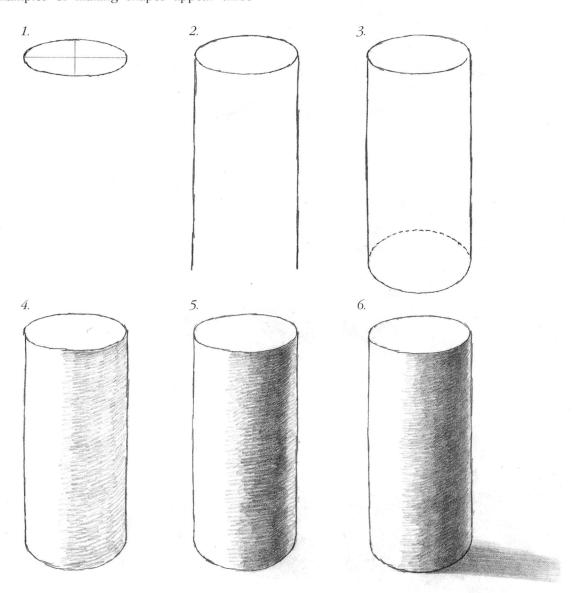

- 1. Draw an ellipse.
- 2. Draw two vertical straight lines from the wo outer edges of the horizontal axis.
- 3. Put in half an ellipse to represent the bottom edge of the cylinder. Or, draw a complete ellipse lightly then erase the half bat would only be seen if the cylinder were ransparent.
- 4. To give the effect of light shining from the left, shade very lightly down the right half of the cylinder.
- 5. Add more shading, this time to a smaller vertical strip that fades off towards the centre.
- 6. Add a shadow to the right, at ground level. Strengthen the line of the lower ellipse.

DRAWING ELLIPSES MECHANICALLY

Initially, you will find ellipses difficult to draw freehand. The only remedy is to keep practising. You might, however, like to try one, or perhaps both, of the mechanical methods I am about to show you. Both demonstrate how an ellipse should look.

METHOD 1

The most difficult aspect of this method is getting the materials together: a board, a sheet of paper, a piece of string and two thumb tacks or drawing pins. The exercise itself is very simple and produces a perfect ellipse.

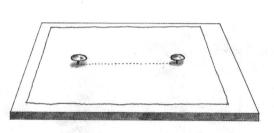

1. Attach the sheet of paper to the board by means of the two tacks or pins, placing them a few centimetres apart.

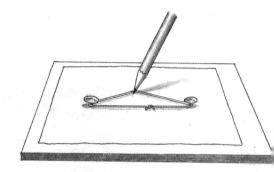

2. Tie a length of thin cord in a loop that will slip over the two pins; the cord shouldn't be much longer than the distance the pins are apart. Place a sharpened pencil inside the locand push it outwards until the string is taut.

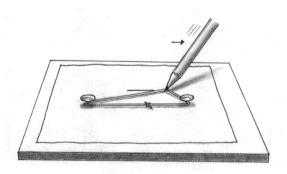

3. Move the pencil in a clockwise direction, ensuring the point is in contact with the paper and you are keeping the cord taut but not stretching it.

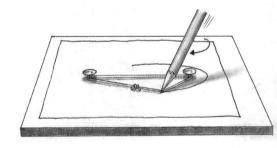

4. As the pencil progresses around the outside limit described by the cord, an elliptical figure will appear on the paper. Continue until you met the point you started at.

METHOD 2

This exercise is time-consuming and rather fiddly but enjoyable if you are interested in geometry or technical drawing. In addition to a

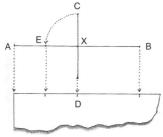

1. On the paper, draw the two axes of an ellipse: a horizontal line (AB) and a shorter vertical line (CD). Make sure the latter is berpendicular. Measure the half length of the vertical axis (CX) along the line of the horizontal axis from the centre of the line (E).

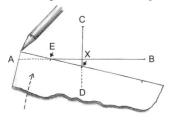

3. Move the strip of paper around as shown, making sure that you keep the mark of the vertical axis (E) on the horizontal line (AB) and the central mark of the horizontal axis (X) on the vertical line (CD). As you move the strip, make a dot where the corner of the paper falls.

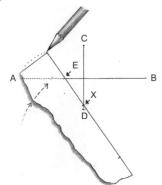

5. The curve of the dots begins to trace out an ellipse.

pencil, you will need a sheet of paper and a strip of paper to use as a measuring device.

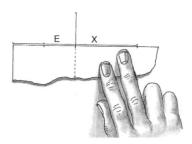

2. Place the straight edge of your strip of paper along the horizontal axis of your lines, ensuring that the corner of this strip is in line with the left end of the axis. Mark halfway along the horizontal line (X) and where the vertical axis meets it (E).

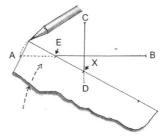

4. If each time you move the strip you make a dot at that corner, and you maintain the alignment on the horizontal and vertical axes, you will produce a series of dots that forms a curve.

6. When you have completed a quarter of your ellipse, proceed so that the vertical mark continues along the horizontal axis line and the halfway mark begins to come back along the vertical axis line. Carry on until the whole of the ellipse has been marked out in a series of dots.

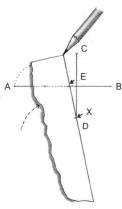

USING TONE

There are many ways of using tone, depending on the effect you are trying to achieve and the materials you are using. The techniques shown here are the ones you will find most useful and effective over a broad range of still-life drawing. As with the previous exercises you have tried, the more you practise the better your expertise with handling tone will become. Start by becoming familiar with the range of exercises provided below.

Pencil Exercises

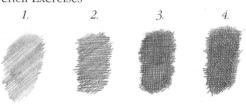

- 1. Draw diagonal lines close together to form an area of tone.
- 2. Draw horizontal lines over the diagonal lines
- 3. Draw vertical lines over the diagonal and horizontal lines.
- 4. Draw diagonal lines in the opposite direction to those shown in 1.

Ink Exercises

This set of technical exercises is to help you get your hand in when you are applying tone with a pen.

- 1. Draw groups of short, fine vertical lines close together but sufficiently apart that the paper shows between each stroke.
- 2. Draw a series of longer strokes.
- 3. Try drawing diagonal strokes close together.
- 4. Draw a set of vertical strokes over the diagonals to create a darker tone.
- 5. Apply a set of horizontal lines over the last two. You can make strokes in as many directions as you like, in layers; eventually you will get a very black tone.

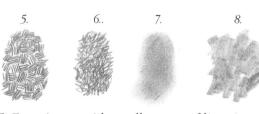

- 5. Experiment with small groups of lines in varying directions.
- 6. Try making random short strokes in any direction but achieving an even effect.
- 7. Lightly draw with a soft pencil and then smudge with your finger.
- 8. Use the edge of the pencil lead to get thicker, softer lines in any direction.

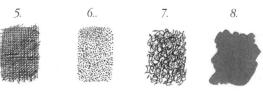

- 6. Now try making lots of small dots with the point of the pen as close together as you can.
- 7. Draw a set of randomly made swirling lines to create a cloudy texture. You need not even take the pen off the paper to achieve this effect.
- 8. Splash on diluted ink with a brush to achieve a medium grey tone.

Applying Tone

Now I want you to practise controlling tone over an area. This requires patient, careful manipulation of the pencil. Regular and diligent practice will pay dividends. Begin by drawing a row of eleven squares.

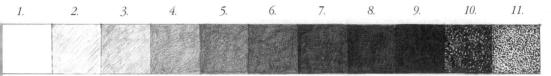

- 1. Leave the first square blank.
- 2. Fill the square with a very light covering of tonal lines.
- 3. Apply a slightly heavier tone all over.
- 4-7 In the next four squares the tone should become progressively heavier and darker until you achieve ...
- 8. ... total black; as black as it gets with pencil.

- 9. Fill in this square with black ink. Now compare the result with No. 8.
- 10. Fill the area with many small, overlapping marks.
- 11. In the final square make many small separate marks that do not quite touch.

Shading Exercises

This series of technical exercises is designed to enable you to control changes of tone over an area.

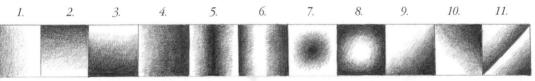

- 1. Shade from the left side fading to white on the right.
- 2. Start at the top and fade towards the bottom.
- 3. Start at the bottom and fade out at the top.
- 4. Start at the right side and fade towards the left; the reverse of the shading in the first square.
- 5. Shade across the centre vertically, fading out 11. Draw a diagonal across the square. In one at either side.

 half shade from the centre fading to one
- 6. Shade from both sides, fading to white in the centre.

- 7. Shade in the central area, fading out to the edges.
- 8. Shade around the edges, fading at the
- 9. Shade from the bottom right corner, fading diagonally towards the top left.
- 10. Shade from top right, fading to bottom left.
- 11. Draw a diagonal across the square. In one half shade from the centre fading to one corner, in the other half shade from the corner fading to the centre.

SIMPLE OBJECTS

When you are able to complete the practices with confidence, it is time to tackle a few real objects. To begin, I have chosen a couple of simple examples: a tumbler and a bottle. Glass

objects are particularly appropriate at this stage because their transparency allows you to get a clear idea of their shape.

In pencil, carefully outline the shape. Draw the ellipses at the top and bottom as accurately as you can. Check them by drawing a ruled line down the centre vertically. Does the left side look like a mirror image of the right? If it doesn't, you need to try again or correct your first attempt. The example has curved sides and so it is very apparent when the curves don't match.

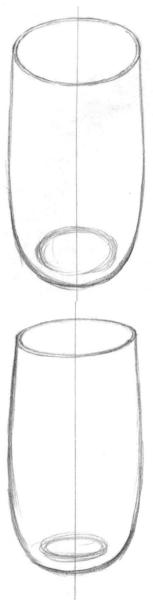

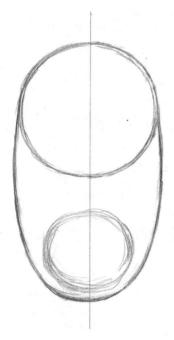

Now shift your position in relation to the glass so that you are looking at it from higher up. Draw the ellipses at top and bottom, then check them by drawing a line down the centre. You'll notice this time that the ellipses are almost circular.

Shift your position once more, this time so that your eye-level is lower. Seen from this angle the ellipses will be shallower. Draw them and then check your accuracy by drawing a line down centre. If the left and right sides of your ellipsed are mirror images, your drawing is correct.

You have to use the same discipline when drawing other circular-based objects, such as bottles and bowls. Here we have two different types of bottle: a wine bottle and a beer bottle. With these I want you to start considering the proportions in the height and width of the objects. An awareness of relative proportions within the shape of an object is very important if your drawings are to be accurate.

After outlining their shapes, measure them carefully, as follows. First, draw a line down the centre of each bottle. Next mark the height of the body of the bottle and the neck, then the width of the body and the width of the neck. Note also the proportional difference between the width and the length. As you can see, in our examples the proportions differ a lot.

The more practice at measuring you allow yourself, the more adept you will become at drawing the proportions of objects accurately. In time you will be able to assess proportions by eye, without the need for measuring. To provide you with a bit more practice, try to draw the following objects, all of which are based on a circular shape although with slight variations and differing in depth.

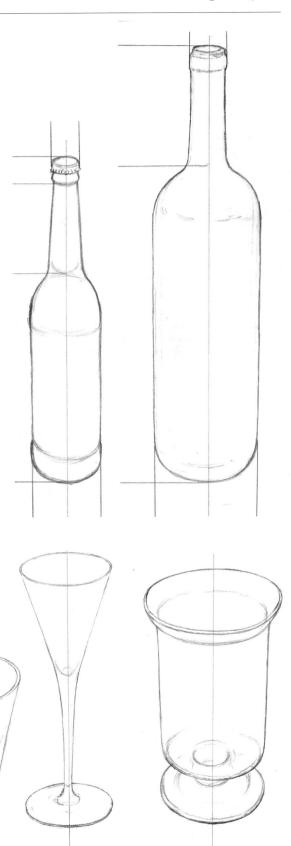

SURFACE TEXTURE

Solid objects present a different challenge and can seem impossibly daunting after you have got used to drawing objects you can see through. When I encourage them to put pencil to paper, novice pupils often initially complain, 'But I can't see anything!' Not true. Solid

objects have one important characteristic that could have been especially designed to help the artist out: surface texture. In the beginning you might find these practices a bit tricky, but if you persevere you will find them immensely rewarding.

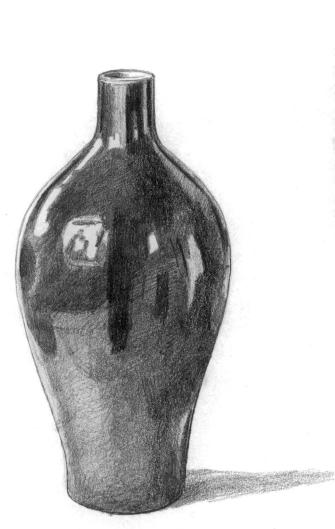

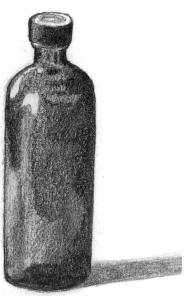

The two darkly glazed objects presented here appear almost black with bright highlights and reflections. Begin by putting in the outlines correctly, then try to put in the tones and reflections on the surface as carefully as you can. You will have to simplify at first to get the right look, but as you gain in confidence you will have a lot of fun putting in detailed depictions of the reflections.

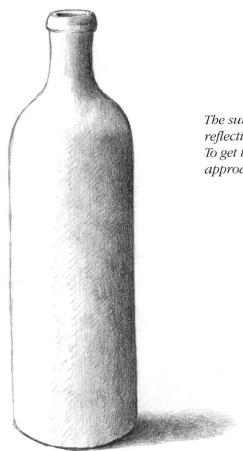

The surface of this matt bottle is nonreflective and so presents a different problem. To get this right you have to take a very subtle approach with the application of tone.

The problem with clear glass is how to make it look like glass. In this example the bright highlights help us in this respect, so put them in. Other indicators of the object's materiality are the dark tones, which give an effect of the thickness of the glass.

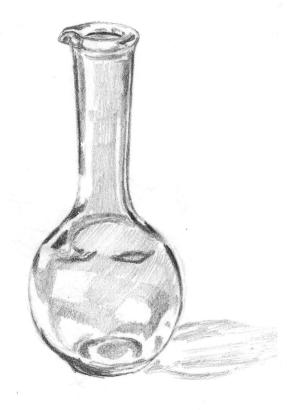

RECTANGULAR OBJECTS

Unlike some other types of drawing, you don't need to know a great deal about perspective to be able to produce competent still lifes.

You will, however, find it useful to have a basic grasp of the fundamentals when you come to tackle rectangular objects.

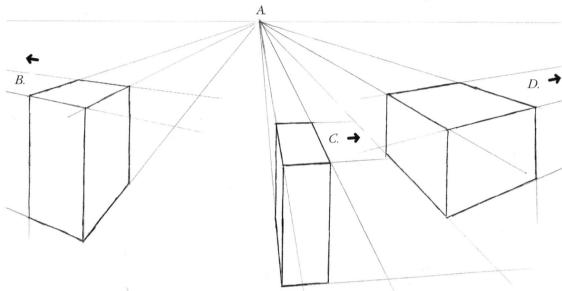

Perspective can be constructed very simply by using a couple of reference points: eye-level (the horizontal line across the background) and (A.) one-point perspective lines (where all the lines converge at the same point).

such as books, cartons and small items of furniture.

The perspective lines relating to the other sides of the object (B. C. D.) would converge at a different point on the eye-level. For the sake of simplicity at this stage, they are shown as relatively horizontal.

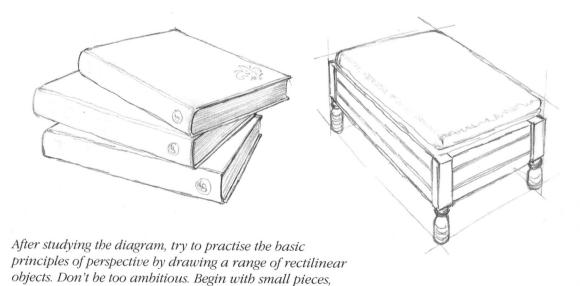

You will find that different objects share perspectival similarities – in my selection, compare the footstool with the pile of books, and the chair with the carton.

The wicker basket and plastic toy box offer slightly more complicated rectangles than the blanket box. With these examples, when you have got the perspective right, don't forget to complete your drawing by capturing the effect of the different materials. Part of the fun with drawing box-like shapes comes in working out the relative evenness of the tones needed to help convince the viewer of the solidity of the forms. In these three examples, use tone to differentiate the lightest side from the darkest, and don't forget to draw in the cast shadow.

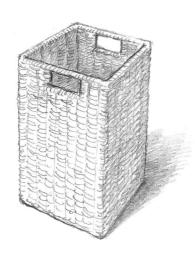

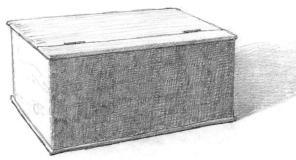

SPHERICAL OBJECTS

You shouldn't find it difficult to practise drawing spherical objects. Start by looking in your fruit bowl, and then scanning your home generally for likely candidates. I did this and came up with an interesting assortment. You will notice that the term spherical covers a

range of rounded shapes. Although broadly similar, none of the examples is identical. You will also find variations on the theme of surface texture. Spend time on these practices, concentrating on getting the shapes and the various textural characteristics right.

For our first practice, I chose an apple, an orange and a plum. Begin by carefully drawing in the basic shape of each fruit, then mark out the main areas of tone.

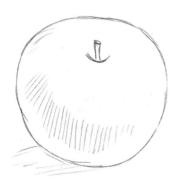

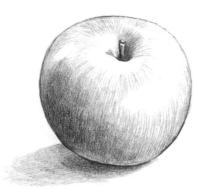

The orange requires a stippled or dotted effect to imitate the crinkly nature of the peel; see the basic patches of tone on pages 20–1 for an example.

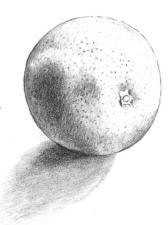

Take the lines of tone vertically round the shape of the apple, curving from top to bottom and radiating around the circumference. Gradually build up the tone in these areas. In all these examples don't forget to draw the cast shadows.

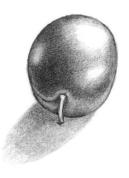

To capture the silky-smooth skin of a plum you need an even application of tone, and obvious highlights to denote the reflective quality of the surface.

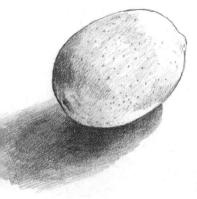

The surface of an egg, smooth but not shiny, presents a real test of expertise in even tonal shading.

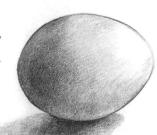

The texture of a lemon is similar to that of the orange. Its shape though is longer.

The shading required for this round stone was similar to that used for the egg but with more pronounced pitting.

The perfect rounded form of this child's ball is sufficiently shiny to reflect the light from the window. Because the light is coming from behind, most of the surface of the object is in shadow; the highlights are evident across the top edge and to one side, where light is reflected in a couple of smaller areas. The spherical shape of the ball is accentuated by the pattern curving round the form.

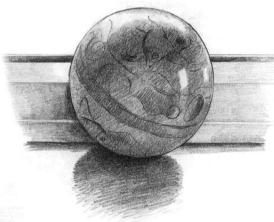

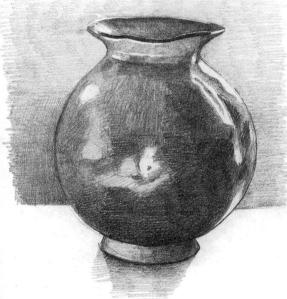

The texture of this hand-thrown pot is not uniform and so the strongly contrasting dark and bright tones are not immediately recognizable as reflections of the surrounding area. The reflections on the surface have a slightly wobbly look.

INTRODUCING DIFFERENT MEDIA

Taking an object and drawing it in different types of media is another very useful practice when you are developing your skills in still life. The materials we use have a direct bearing on the impression we convey through our drawing. They also demand that we vary our technique to accommodate their special characteristics. For the first exercise I have chosen a cup with a normal china glaze but in a dark colour.

Drawn in pencil, each tonal variation and the exact edges of the shape can be shown quite easily – once you are proficient, that is.

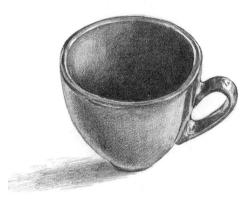

Attempt the same object with chalk (below) and you will find that you cannot capture the precise tonal variations quite so easily as you can with pencil. The coarser tone leaves us with the impression of a cup while showing more obviously the dimension or roundness of the shape. A quicker medium than pencil, chalk allows you to show the solidity of an object but not its finer details.

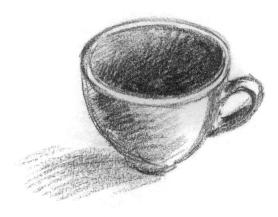

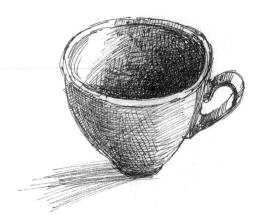

Although ink (left) allows you to be very precise, this is a handicap when you are trying to depict the texture of an object. The best approach is to opt for rather wobbly or imprecise sets of lines to describe both the shape and texture. Ink is more time-consuming than either pencil or chalk but has the potential for giving a more dramatic result.

If you want to make what you are drawing unmistakable to the casual viewer, you will have to ensure that you select the right medium or media. Unfortunately for the beginner, in this respect the best result is

sometimes achieved by using the most difficult method. This is certainly the case with our next trio, where wash and brush succeed in producing the sharp, contrasting tones we associate with glass.

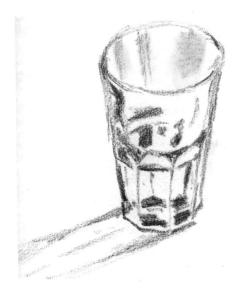

Although this example in chalk is effective in arresting our attention, it gives us just an impression of a glass tumbler.

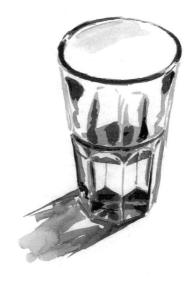

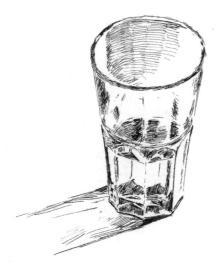

Pen and ink is a very definite medium to work in. Here it allows the crispness of the glass edges to show clearly, especially in the lower half of the drawing.

UNUSUAL SHAPES

When you have learnt to draw simple shapes effectively, the next step is to try your hand at more complicated versions of these shapes. In this next selection, the first set of examples

have an extra part or parts jutting out from a main body, in the form of spouts, handles and knobs. Finally, we look at more subtle changes in shape across a range of objects.

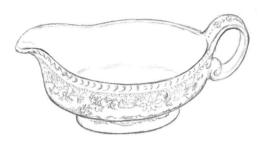

These two items provide some interesting contrasts in terms of shape. Note the delicate pattern around the lip of the sauce-boat which helpfully defines the shape of the outside against the plain white surface of the inside. The main point about the jug is the simple spout breaking the curve of the lip.

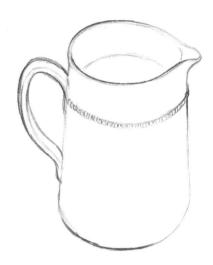

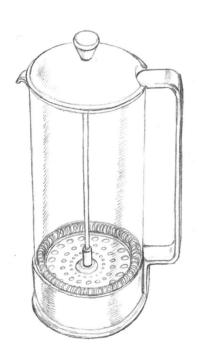

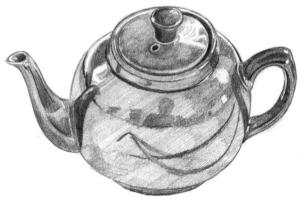

With our next pairing, of teapot and cafetière, the most obvious point of contrast – apart from the relative sizes and shapes of the spouts and handles – is the texture. The cafetière is very straightforward, requiring only that you capture its cylindrical shape and show its transparency. The teapot is more interesting: a solid spherical shape with a dark shiny surface and myriad reflections. When you practise drawing this type of object ensure that the tones you put in reveal both its surface reflections and underlying structure.

In the following examples there is a hint of continuous form rather than bits being added on.

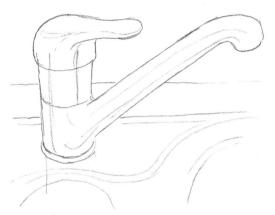

A set of cutlery presents quite elegant shapes. The principal difficulty here is rendering accurately the proportion between the business end and the handle of each item. I grouped them close together to help contrast the shapes and make them easier to get right.

The shape of this metal mixer tap is not complicated and should present few problems.

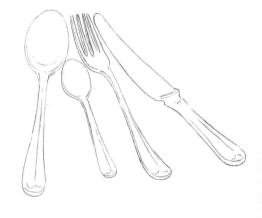

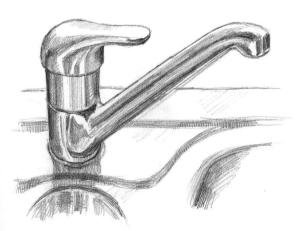

Once you are happy with the accuracy of your outline drawings, you can enjoy the process of carefully putting in the tonal reflections. With any shiny metallic object the contrast between darks and lights will be very marked, so ensure that you capture this effect with your use of tone.

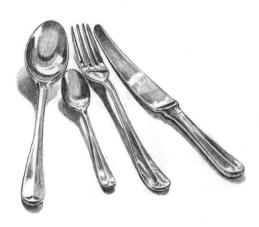

UNUSUAL SHAPES: WASH AND BRUSH EXERCISE

Next, to vary the technique of your drawing, switch to a brush and tonal wash, using either ink or watercolour. For this exercise I have chosen a shiny saucepan. As you will have already discovered when carrying out some of

the practices on the previous pages, obtaining a realistic impression of a light-reflecting material such as metal can only be achieved if you pay particular and careful attention to the tonal contrasts.

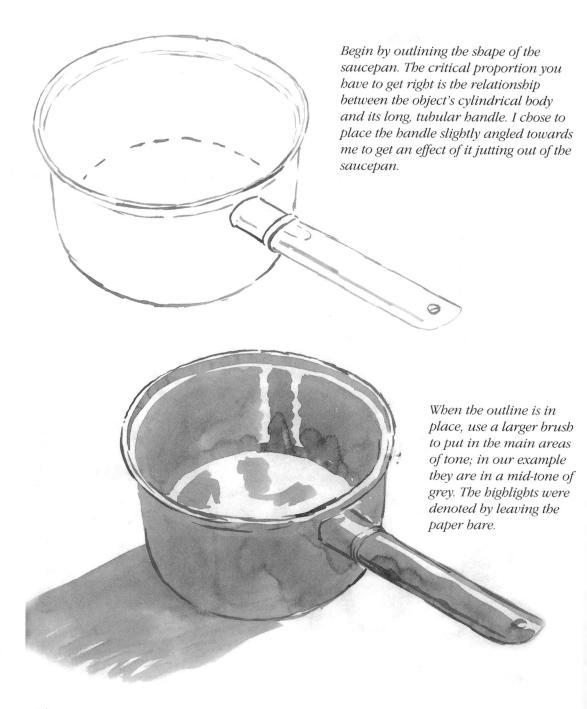

over them with white gouache to re-

establish the highlights.

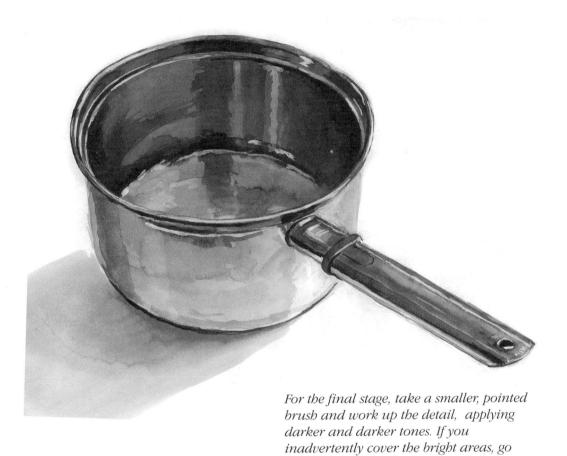

UNUSUAL SHAPES: GROUP PRACTICE

In perspective terms, one object by itself doesn't tell you as much as several grouped together. I have selected a few tools for this next exercise, arranging them so they fan out with either the working ends or the handles towards you. Sharply defined shapes such as

these are relatively easy to draw, so long as you take care over getting the proportions right. Note carefully the angles at which they appear to be lying on the surface. Their proportions are not quite the same as they would be if they were held straight in front of the eye.

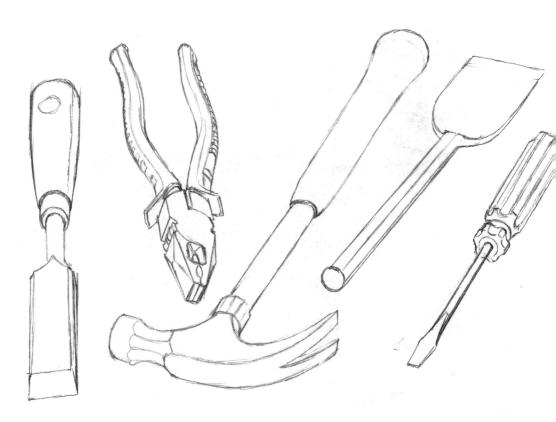

To begin this type of drawing you have to take some form of measurement to ensure that you don't make the length of the head or handle of each tool longer or shorter than it should be. When you are sure of the proportions and perspective, draw each tool in outline as accurately as you can, defining the edges clearly.

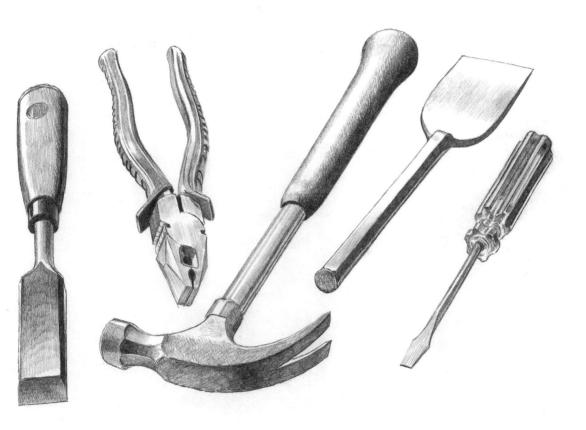

Clarity of definition is very important when drawing objects that have been designed to do a job. If your outline drawings are not accurate the addition of tone will not make them any better. Assuming that your outlines are spot-on, proceed to put in the tones,

denoting differences between the various materials of which the tools are made: for example, the sharp contrasts between dark and light in metallic parts and the more subdued tones for parts made of rubber, plastic or wood.

UNUSUAL SHAPES: PRACTICE

We finish this brief introduction with a range of common household items for you to practise. The subject matter for still-life compositions is massive, so the more varied your experience of drawing different kinds of objects, in terms of shape, size and texture, the wider will be the possibilities open to you. As with any kind of drawing you have to work up a body of experience before you can get the best out of it. My hope is that this section has encouraged you to start the journey along this path.

This basketwork chair could easily be the centre of a largish still-life arrangement. You need to get the outline shape right first. Because it is a large object, you will find it easier to do this if you stand back and view it from a distance where you can take in the whole shape in one glance. Of particular interest is the difference in texture between the softness of the cushions and the tightly woven basketwork of the chair itself. Notice too the legs jutting out backwards, and the softening effect of the heavily woven edge of the back and arms. Capturing the texture of the material is easier than you might think; look at it closely and you will see it is just sets of horizontal curves lying in columns across the surface of the chair. The bare wooden floor with its clearly defined boards assists in the depiction of the chair's threedimensional shape.

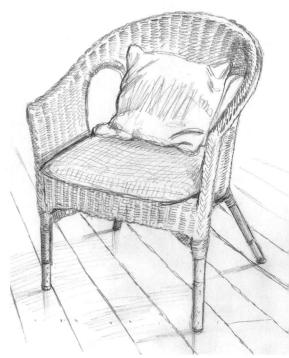

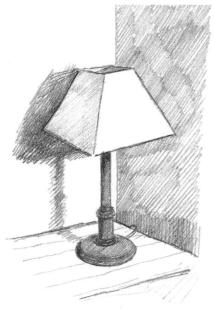

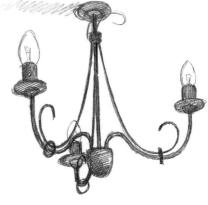

At first glance you may consider this chandelier and lamp a bit too simple. Both are relatively easy to draw. The interesting – and important – aspect of these two objects is the cast shadow, which in both cases is part of the artist's means of placing an object in situ.

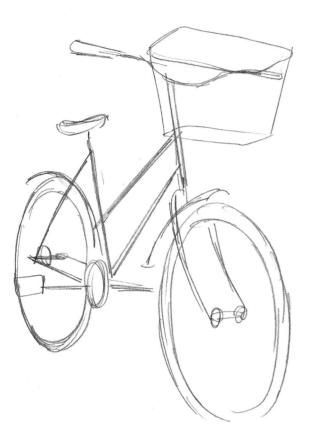

Our final object is a bit bigger than the chair and much more complicated: a bicycle. Although it presents difficulties, there is not much in the way of solid forms to draw, thanks to its linear construction.

The lack of depth in the parts making up the shape means that your initial drawing will probably look very rudimentary. Don't worry about this; concentrate on trying to work out the proportion of, say, the ellipses of the wheels in relation to the structure of the frame.

You may require several attempts before you can produce a convincing bicycle shape. Do keep at it, because this whole exercise provides excellent training for the eye and hand. This object is a bit like drawing a skeleton for a human figure. The structural shape is everything, because this is what makes it work. There are no unnecessary bits and pieces on a machine like this.

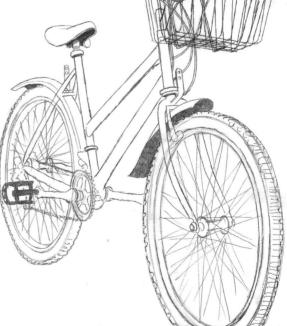

Exploring Textures

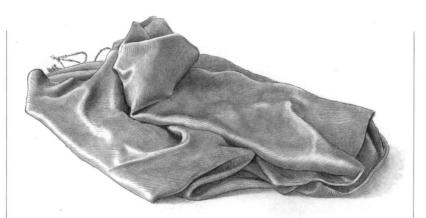

NCE YOU HAVE BEGUN THE PROCESS of mastering the drawing of the shapes of the various objects that can form a still-life composition, you have to turn your attention to showing the different qualities of the materials that these objects are made of. In the early days of still-life painting the fame of artists rested upon their ability to paint a group of objects so life-like that their surface, whatever the nature of their texture, was almost tangible.

Flemish and Dutch artists were particularly famed for their ability to bring their subject matter to life in this regard, as were the Spanish and French. These artists took delight in including in their pictures a large variety of materials, such as glass, wood, stone, shells, flowers and various kinds of food, including dead animals. This tradition is still alive and even now there are still-life artists who can produce pictures of such immaculate brilliance that you feel that you can almost taste the food or pick up the objects they portray.

The ability to differentiate between textures in one picture and to give a sense of the feel of the objects you draw is a skill that you must develop if you want to produce good work in this genre. In this section you will find practice exercises to help your development, starting with simple textures and gradually introducing more complex examples.

Don't forget that what you are doing is in fact making marks on the paper with pencil, pen or brush. Given that fact, the whole solution to producing the effects of the texture of the material of the objects' surface is in the manipulation of the marks you are going to make. You are not drawing cloth, fur or glass, you are drawing lines or dots or patches of tone which, if placed together in an artistic way, will convince the eye that the object drawn is indeed made of that substance. So the whole thing is a trick. You are creating an illusion of texture, because in fact it is just pencil marks, or pen marks, or brush marks. What you need to consider is only the arrangement of the marks you make and their intensity or tone.

What I've tried to explain in this section is what to look for in the object and what that means in terms of the way you draw the lines or tones on the paper.

One of the great lessons one learns when trying to express the materiality of an object is how much information our eyes give us, even when we have taken only a very quick look at it. The effort to understand what it is we are seeing in visual terms helps us to see more when we look again, and gradually you will find that the more you understand what you are actually seeing, the more interest you will have in looking at the physical world. It really does enliven your life, this drawing business.

TEXTILES

The best way to understand the qualities of different textures is to look at a range of them. We'll begin by examining different kinds of textiles: viscose, silk, wool and cotton. Key with each example is the way the folds of cloth

drape and wrinkle. You will need to look carefully too at the way the light and shade fall and reflect across the folds of the material, because these will tell you about the more subtle qualities of the surface texture.

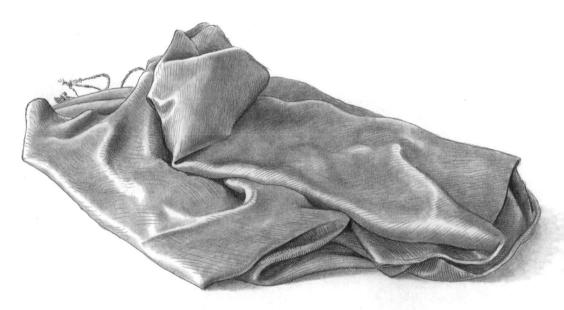

This scarf or pashmina made of the synthetic material viscose is folded over upon itself in a casual but fairly neat package. The material is soft and smooth to the touch, but not silky or shiny; the folds drape gently without any harsh edges, such as you might

find in starched cotton or linen. The tonal quality is fairly muted, with not much contrast between the very dark and very light areas; the greatest area of tone is a medium tone, in which there exists only slight variation.

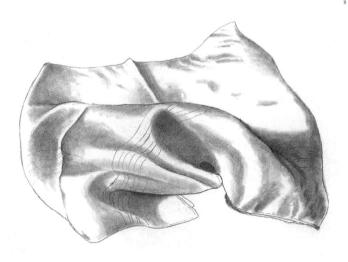

A silk handkerchief which, apart from a couple of ironed creases in it, shows several smooth folds and small undulations. The tonal qualities are more contrasting than in the first example – the bright areas ripple with small patches of tone to indicate the smaller undulations. We get a sense of the material's flimsiness from the bem and the pattern of stitched lines.

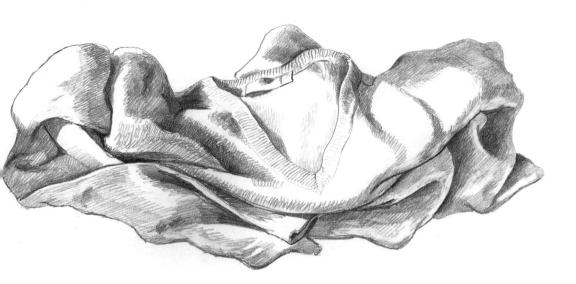

The folds in this large, woolly jumper are soft and large. There are no sharp creases to speak of. Where the two previous examples were smooth and light, the texture here is

coarser and heavier. The showing of the neckline with its ribbed pattern helps to convince the eye of the kind of texture we are looking at.

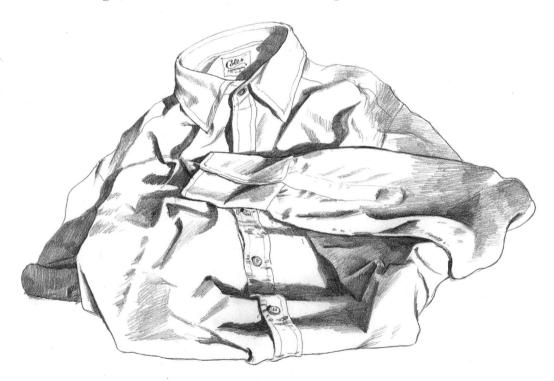

This well-tailored cotton shirt is cut to create a certain shape. The construction of the fabric produces a series of overlapping folds. The collar and the buttoned fly-front give some structure to the otherwise softly folded material.

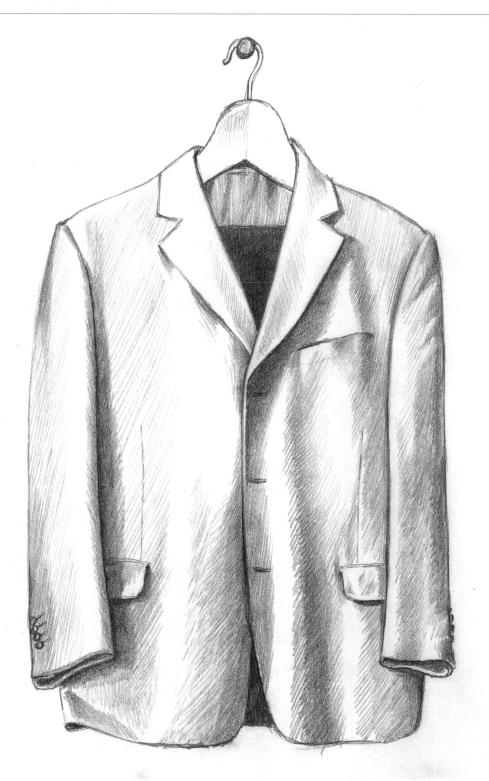

A wool jacket, tailored like the shirt on the previous page. Its placement on a hanger gives us a clear view of the object's shape

and the behaviour of the material. The few, gentle folds are brought to our attention by the use of tone.

A deck shoe in soft leather, with soft edges and creases across the toe area, has none of the high shine of formal shoes. The contrast between the dark inside of the shoe and the lighter tones of the outside help to define the overall texture.

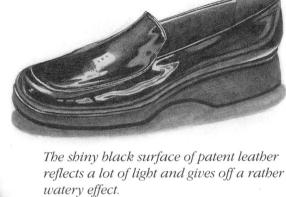

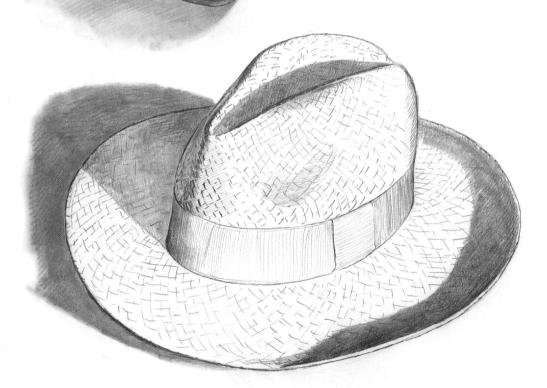

A straw hat produces a clear-cut form with definite shadows that show the shape of the object clearly. The texture of the straw, woven across the structure, is very

distinctive. Well-worn hats of this kind tend to disintegrate in a very characteristic way, with broken bits of straw disrupting the smooth line.

EXERCISES WITH PAPER

Now we have a look at something completely different. In the days when still-life painting was taught in art schools the tutor would screw up a sheet of paper, throw it onto a table lit by a single source of light, and say, 'Draw that.' Confused by the challenge, many students were inclined to reject it. In fact, it is not as difficult as it looks. Part of the solution to the

problem posed by this exercise is to think about what you are looking at. Soon you will realize that although you have to try to follow all the creases and facets, it really doesn't matter if you do not draw the shape precisely or miss out one or two creases. The point is to make your drawing look like crumpled paper, not necessarily achieve an exact copy.

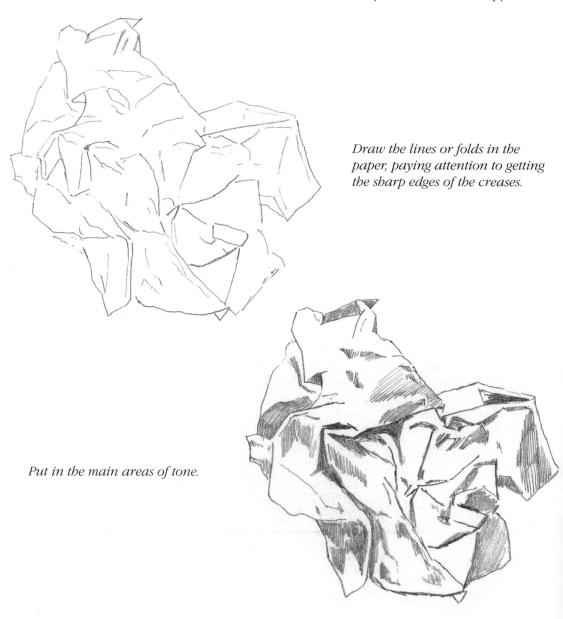

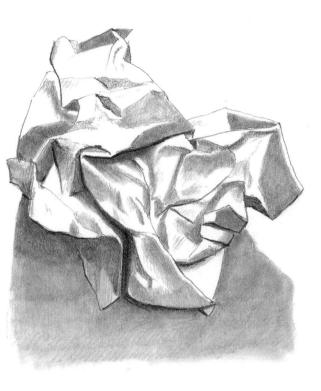

Once you have covered each tonal area, put in any deeper shadows, capturing the contrasts between these areas.

When you have completed the last exercise, try a variation on it. Crumple a piece of paper and then open it out again. Look at it and you will see that the effect is rather like a desert landscape. Before you try to draw it, position the paper so that you have light coming from one side; this will define the facets and creases quite clearly and help you.

Follow the three steps of the previous exercise, putting in the darkest shadows last.

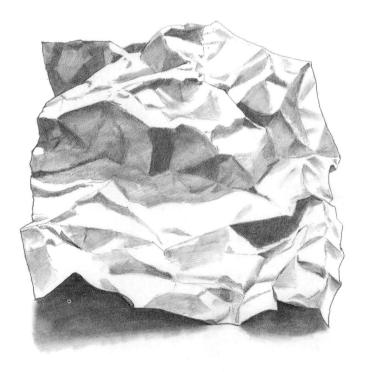

GLASS

Glass is a great favourite with still-life artists because at first glance it looks almost impossible to draw. All the beginner needs to remember is to draw what it is that can be seen behind or through the object. The object is to differentiate between the parts that you can see through the object and the reflections that stop you seeing straight through it. You will find, as with this example, that some areas are

very dark and others very bright and often close up against each other. The highlights reflect the brightest light, and whatever is behind the glass is a sort of basis for all the brighter reflections.

Make sure that you get the outside shape correct. When you come to put in the reflections, you can always simplify them a bit. This approach is often more effective than over-elaborating.

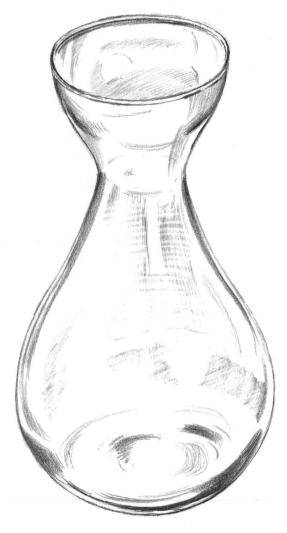

A glass vase, set in front of a white area of background. This allows you to see the shape of the glass very clearly. The tonal areas here will be minimal. If you are not sure whether to put in a very light tone, leave it out until you have completed the drawing, then assess whether putting in the tone would be beneficial.

Draw the outline of this glass as carefully as you can. The delicacy of this kind of object demands increased precision in this respect.

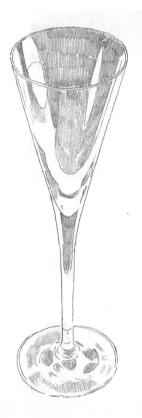

When you are satisfied you have the right shape, put in the main shapes of the tonal areas, in one tone only, leaving the lighter areas clear.

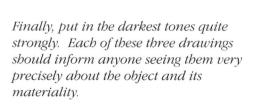

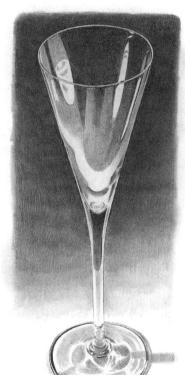

METAL

Now we look at metal objects. Here we have a brass lamp and a silver candlestick, which gives some idea of the problems of drawing metallic surfaces. There is a lot of reflection in these particular objects because they are highly polished, so the contrast between dark and light tends to be at the maximum. With less polished metalware the contrast won't be so strong.

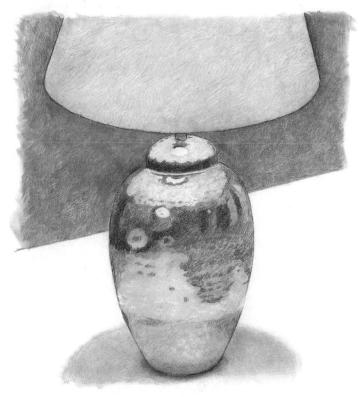

The beaten surface of this brass lamp gives the object many soft-edged facets. Because the light is coming from above, the darkest tones are immediately next to the strong, bright area at the top. The area beyond the darker tones is not as dark because it is reflecting light from the surface the lamp is resting on.

A silver candlestick does not have a large area of surface to reflect from. Nevertheless the rich contrast of dark and light tones gives a very clear idea of how metal appears. Silver produces a softer gleam than harder metals. Note how within the darker tones there are many in-between tones and how these help to create the bright, gleaming surface of our example.

Take your time with this sort of object. It requires quite a bit of dedication to draw all the tonal shapes correctly, but the result is worth it. Your aim must be for viewers to have no doubt about the object's materiality when you have completed the drawing.

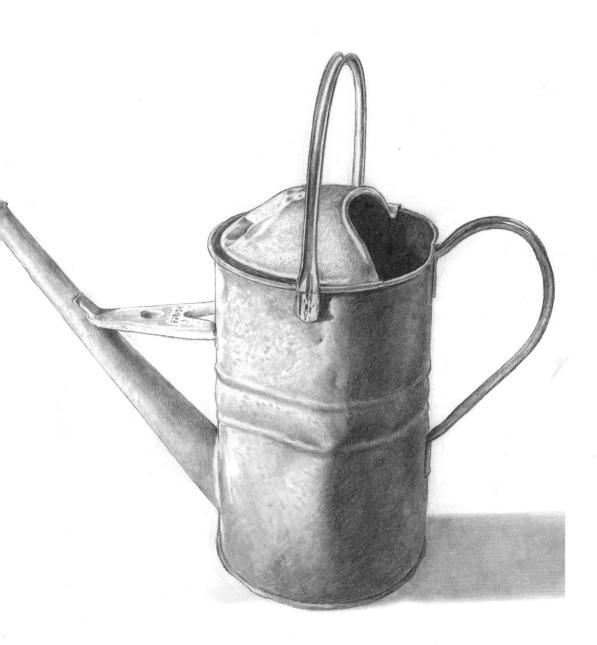

This battered old watering can made of galvanized metal has a hammered texture and many large dents. The large areas of dark and light tone are especially important

in giving a sense of the rugged texture of this workaday object. No area should shine too brightly, otherwise the surface will appear too smooth.

BONES AND SHELLS

Skeletons are always interesting to draw because they provide strong clues as to the shape of the animal or human they once supported. They are often used in still-life arrangements to suggest death and the inevitable breaking down of the physical body that is its consequence. Some people may find them rather uncomfortable viewing because of this, but for the artist they offer fabulous opportunities to practise structural drawing, requiring all our skills to portray them effectively.

This old sheep's skull found on a hillside in Wales still retains a semblance of the living animal, despite the extensive erosion. The challenge for the artist is to get the dry, hard, slightly polished effect of the old weathered bone.

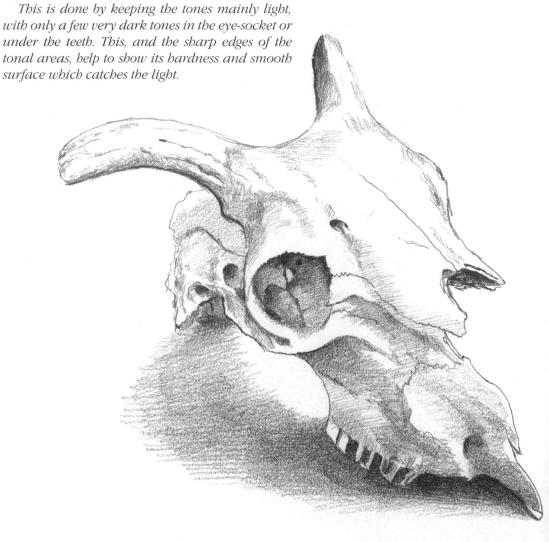

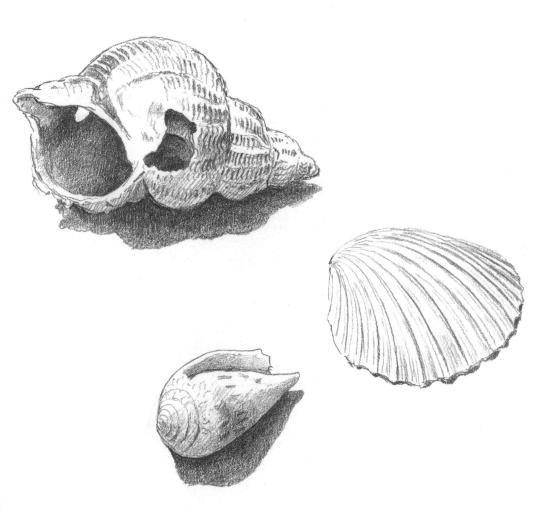

In contrast to the type of skeleton found in mammals and humans, the exo-skeleton lies outside the body. These shells are all that remain of the molluscs they once shielded. As with the sheep's head, each one reveals the characteristic shape of its living entity. Shells offer the artist practice in the drawing of unusual and often fascinating shapes, as well as different textures ranging from smoothly polished to craggy striations.

STONE

Natural materials such as rock offer a host of opportunities in terms of their materiality. All

of the following are hard, solid objects, but that is about as far as the visual similarities go.

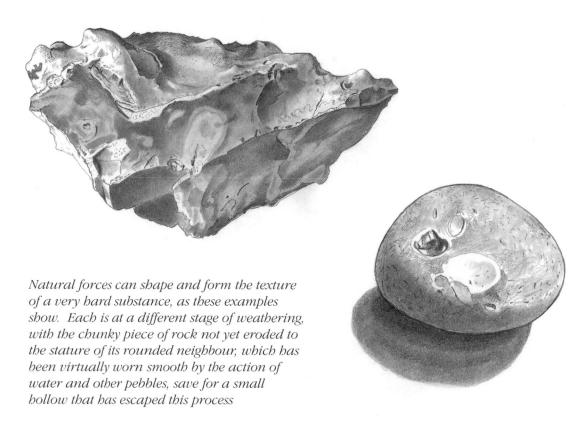

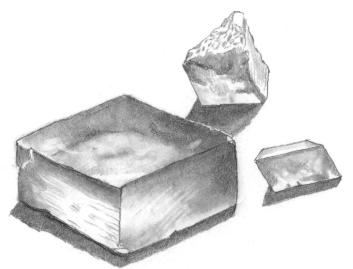

These pieces of feldspar present a different sort of smoothness, an almost glass-like surface in contrast to the opaque solidity of the previous examples.

WOOD

In its many forms, wood can make an attractive material to draw. Here the natural deterioration

of a log is contrasted with the man-made construction of a wooden box.

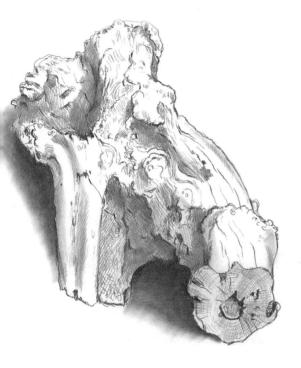

The action of water and termites over a long period has produced a very varied surface on the sawn-off log; in some places it is crumbling and in others hard and smooth and virtually intact apart from a few cracks. The weathering has produced an almost baroque effect.

By contrast, this wooden box presents beautiful lines of growth which endow an otherwise uneventful surface with a very lively look. The knots in the thinly sliced pieces of board give a very clear indication of the material the box is made of.

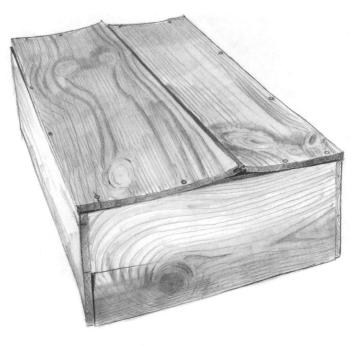

CONTRASTING TEXTURES

If we succeed in capturing an object's surface, it is very likely we will also manage to convey its presence. Our two man-made objects, a glazed vase and a teddy bear, offer different types of solidity, while the range of plants

shown on the facing page test our ability to describe visually the fragility of living matter. The artist should always aim to alter his approach to suit the materiality of the object he is drawing.

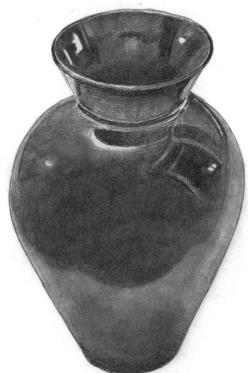

The effects produced by the brilliant glaze on this rather beautiful vase are not so difficult to draw. The reflections are strong and full of contrast, giving us glimpses of the light coming through surrounding windows. They do not, bowever – as is the case with metallic objects – break the surface into many strips of dark and light; check this difference for yourself by looking at the objects shown on pages 50–1.

Teddy bears are very attractive to young children and Paddington Bear is particularly so because of the many stories told about him. This particular soft toy incorporates various textures and qualities: the cuddly softness of the character himself, the shiny softness of the plastic boots, the hardness of the wooden toggles and the rather starchy material of the floppy hat and duffle coat.

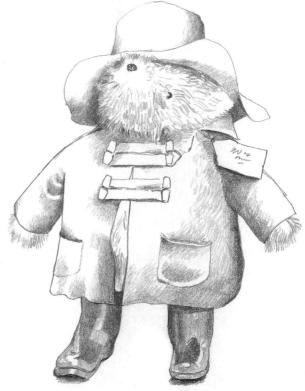

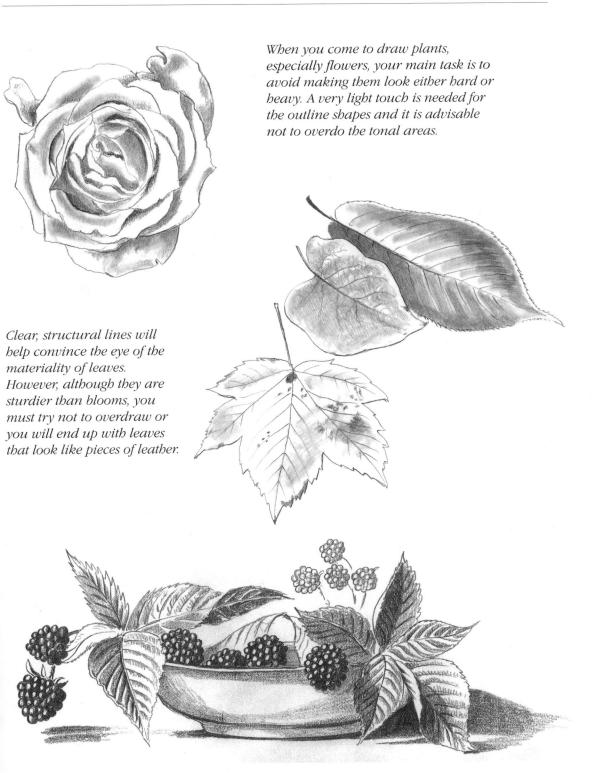

The shiny, dark globes of the blackberries and the strong structural veins of the pointed leaves make a nice contrast. The berries are just dark and bright whereas the leaves have some mid-tones that accentuate the ribbed texture and jagged edges.

FOOD

Food is a subject that has been very popular with still-life artists through the centuries, and has often been used to point up the transience of youth, pleasure and life. Even if you're not inclined to use food as a metaphor, it does offer some very interesting types of materiality that you might like to include in some of your compositions.

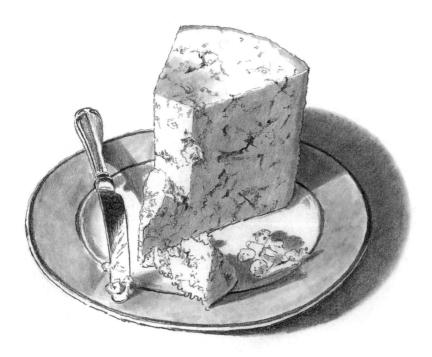

A piece of Stilton cheese, slightly crumbly but still soft enough to cut, is an amazing pattern of veined blue areas through the creamy mass. To draw this convincingly you need to show the edge clearly and not overdo the pattern of the bluish veins. The knife provides a contrast in texture to the cheese.

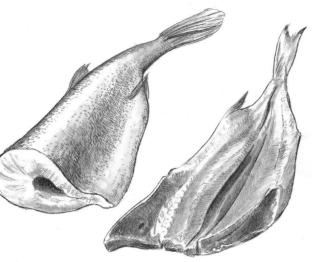

Two views of fish with contrasting textures: scaly outer skin with bright reflections, and glistening interior flesh. Both shapes are characteristic, but it is the textures that convey the feel of the subject to the viewer.

This large cut of meat shows firm, whitish fat and warm-looking lean meat in the centre. Although the contrast between these two areas is almost enough to give the full effect, it is worth putting in the small fissures and lines of sinew that sometimes pattern and divide pieces of meat.

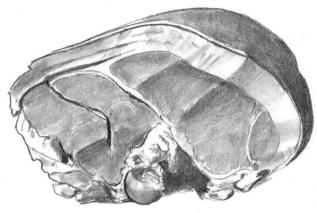

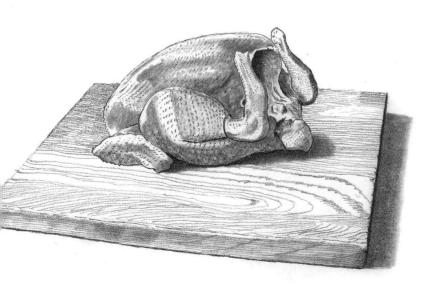

A marked contrast in textures, with a plump chicken appearing soft against the grained surface of a wooden chopping board. Careful dabbing with a pointed bit of kneadable eraser has given a realistic goosebump look to darker areas of the chicken's skin and where there are shadows.

Combining Objects

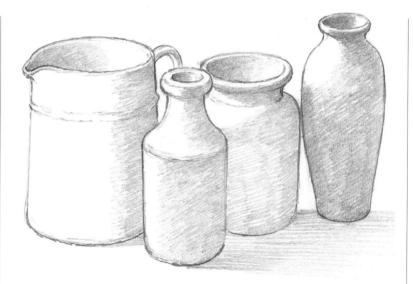

HEN YOU HAVE WORKED HARD at getting the individual objects accurately drawn and giving some idea of their texture, you are ready to start the process of setting up a complete still-life group. There are no rules for this, just myriad approaches. Still life has a long and healthy tradition of not setting limits on artists. No matter how brilliantly individual artists have done by producing particular works, there are no limits to the way the subject can be tackled, so don't be afraid to experiment.

One of the best methods of learning about still-life composition is to look at the works of other artists; not to copy them exactly for the sake of it, but to understand approaches that might work for you. There are many excellent works by

artists in this genre and they represent a rich and stimulating source of practice. Obvious artists to look at are Morandi, Chardin, Melendez, Claesz, Cotan, Cézanne, Picasso and Matisse. These are just a few, but there are many others.

Begin by drawing fairly simple and straightforward arrangements. Don't spread your objects out too much. Concentrate on seeing how a series of overlapping shapes can build a different overall shape. Try out contrasting materials to see how they alter the look of your picture. It is great fun to try different combinations of shapes or to experiment with harmonizing shapes where all the objects are similar. Sometimes the lighting or the size of your chosen objects will demand a specific treatment, but when these restrictions do not apply, always aim to have a go at as many different approaches as you can.

Take your time, avoiding the temptation to get too complicated too early. If you do become overambitious, you will only end up frustrating yourself and becoming perhaps needlessly disillusioned. So, be content to take things slowly, and enjoy the process.

With experience will come the ability to see arrangements that have come about by chance. Someone is about to cook, for example, and has placed various ingredients and pots together on a surface; or someone has just come into the house and carelessly thrown their coat, hat and scarf over a chair and kicked off their shoes. It is very difficult to arrange anything as interestingly or as naturally as it happens by chance. Like most artists, you will have to be satisfied with making arrangements. But do notice the accidental ones because these will inform your own arrangements, and have a good time playing with these.

APPROACHES

Once you reach this stage in your learning process, the actual drawing of individual objects becomes secondary to the business of arranging their multifarious shapes into interesting groups. Many approaches can be used, but if you are doing this for the first time it is advisable to start with the most simple and obvious.

Put together three or four objects of the same type and roughly similar size. Place them close together. The effect, especially if you place them against a neutral background, is a harmonic arrangement of closely related shapes.

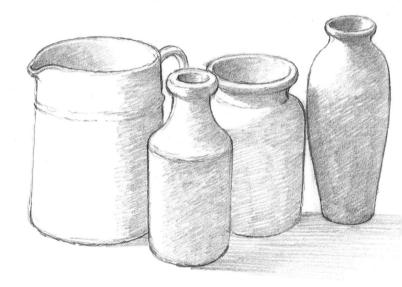

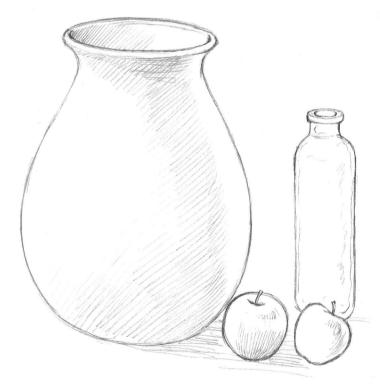

Now try the opposite. Find several objects that contrast radically in size and shape: something large and bulky, something small and neat, and something tall and slim.

Contrast is the point of this combination, so when considering the background go for a contrast in tone.

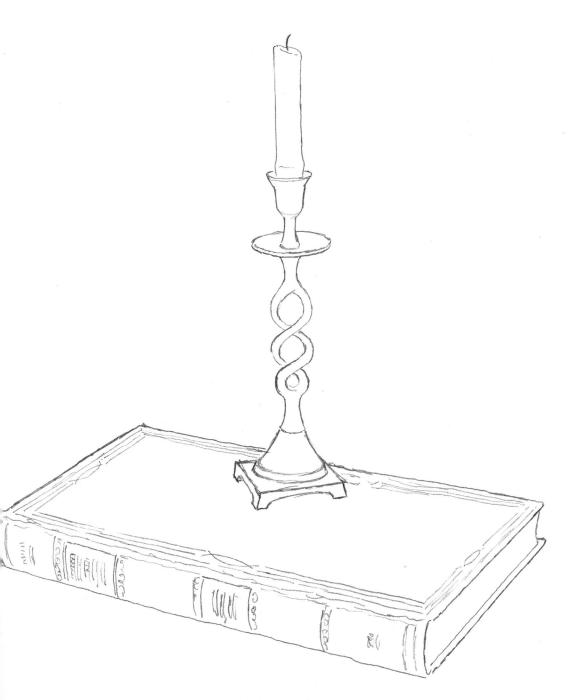

Another version of this approach is combining a tall, spindly object with a solid, flat object. The candlestick and book shown in our example are obvious contrasts.

Neither object by itself would work well as a composition.

APPROACHES

In this spread we are going to play the numbers game and show how the number of objects included in an arrangement changes the feel or dynamic of the group. The aim of this exercise is to show you how you can slowly

build up your still-life composition if you try drawing them bit by bit. By adding more as you go along, you will begin to see the possibilities of the composition.

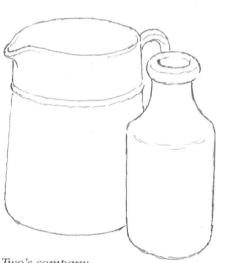

Two's company ...

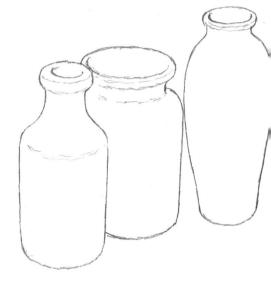

Three's not quite a crowd ...

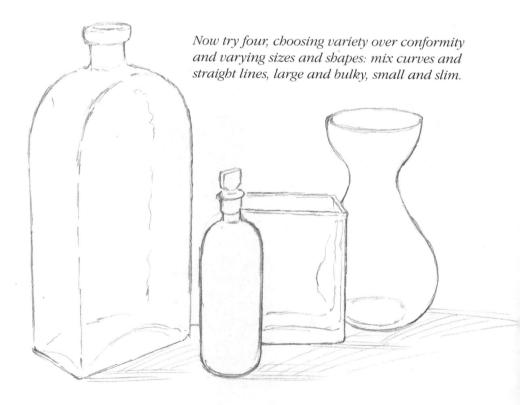

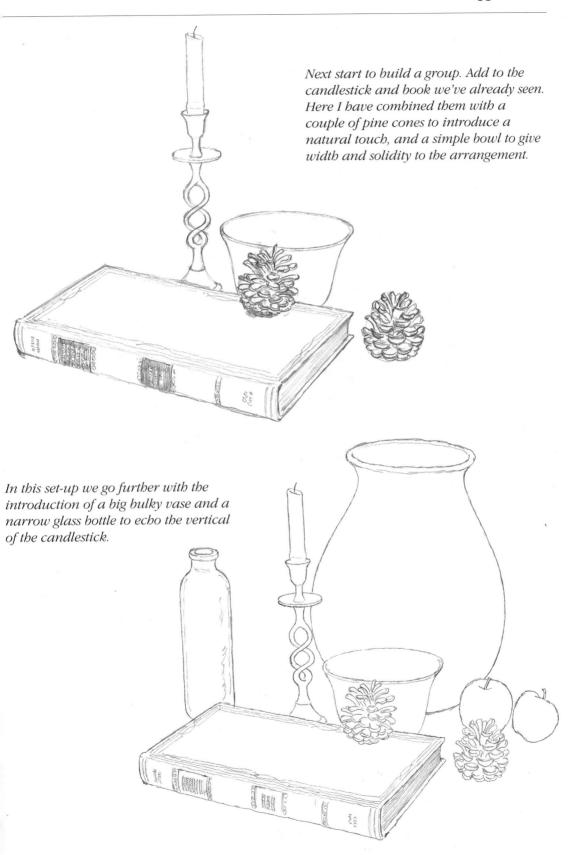

ENCOMPASSED GROUPS

Sometimes the area of the objects you are drawing can be enclosed by the outside edge of a larger object which the others are

residing within. Two classic examples are shown here: a large bowl of fruit and a vase of flowers.

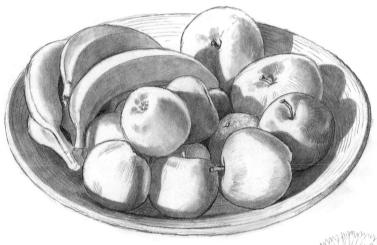

With this type of still life you get a variety of shapes held within the main frame provided by the bowl.

A large vase filled with flowers can be a very satisfying subject to draw. These sunflowers in a large jug make quite a lively picture: the rich heavy heads of the blooms contrast with the raggedy-edged leaves dangling down the stalks, and the simplicity of the jug provides a solid base.

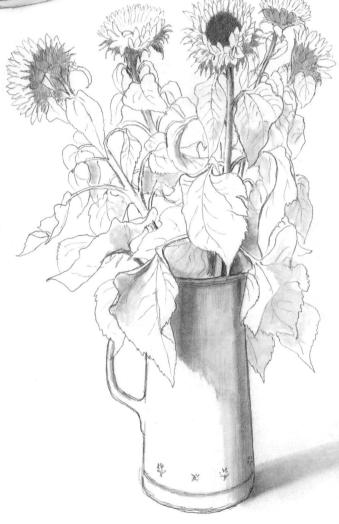

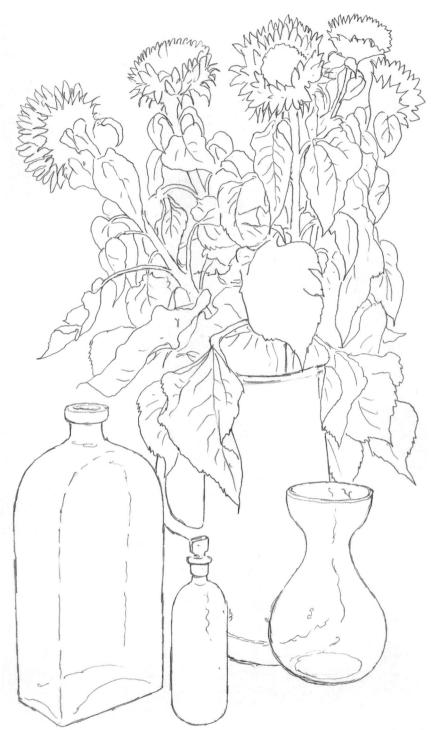

If you were to take the same jug of flowers seen in the previous arrangement and place it among other objects of not too complicated shape, you would get an altogether different composition and yet one that is just as lively.

Particularly noteworthy is the relationship between the smooth rounded shapes in the lower half of the picture and the exuberant shapes of the flowers and leaves in the upper part of the composition.

MAKING SPACES

An important part of composition that is often overlooked is the relationship of the shapes or spaces between objects and the objects themselves. These spaces must be taken into account when you are combining objects. Every artist has to learn that when it comes to drawing a group of objects there are no

unimportant parts. The spaces or shapes between objects are known as negative shapes. In any composition they are as important as the objects themselves, irrespective of whether you are creating an 'ordinary' sort of picture or something you consider really interesting. Study the following examples.

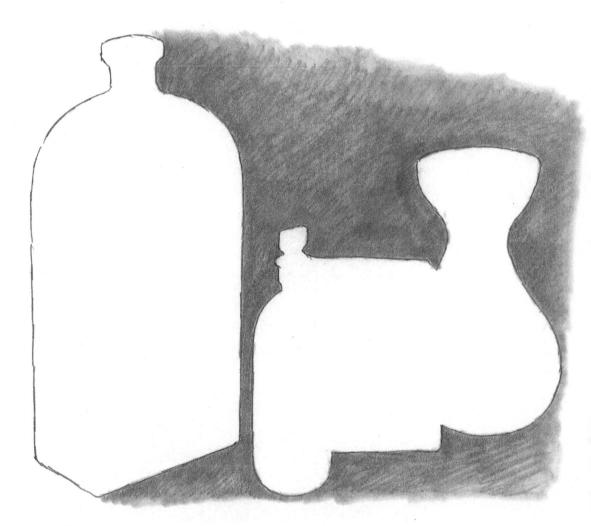

This drawing and that at the top of the facing page were made from groupings seen earlier in the section. Look at the originals (on pages 64 and 62 respectively) and see if you can make out the negative shapes without referring

to the pictures shown here. Apply the lesson to your own compositions and try to appreciate how the shapes that make up an empty background have as much effect on your final drawing as does your choice of objects.

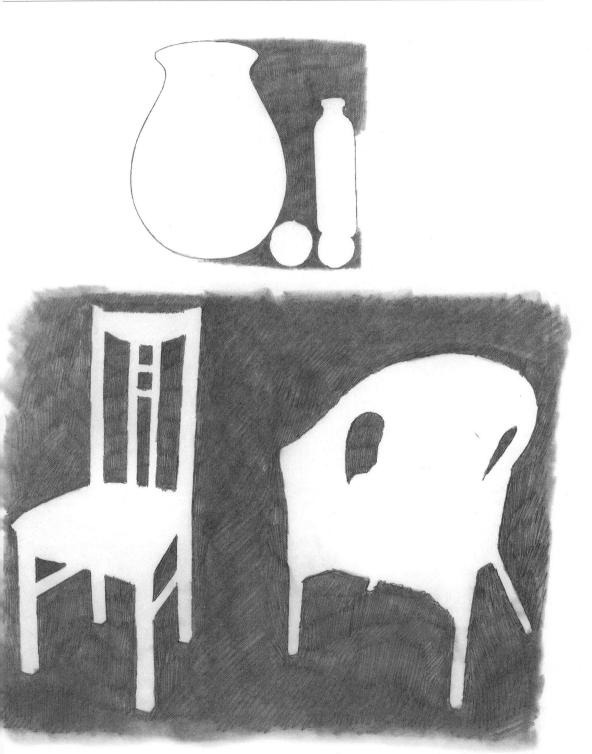

Objects like furniture clarify the lesson of negative space. Look at these two chairs and you will realize that the definition of the spaces between the legs and arms and the

back of the chair describe the objects precisely. The negative spaces are telling us as much about the shapes of the objects as we could discover if they were actually solid.

MEASURING UP

One of your first concerns when you are combining objects for composition will be to note the width, height and depth of your arrangement, since these will define the format and therefore the character of the picture that you draw. The outlines shown below – all of which are after works by masters of still-life composition – provide typical examples of arrangements where different decisions have been made.

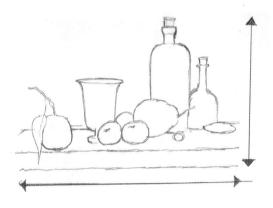

In our first example (after Chardin) the width is greater than the height and there is not much depth.

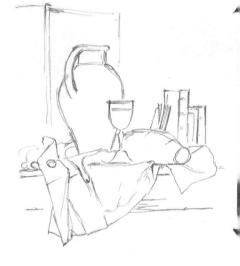

The height is the dominant factor in our second example (also after Chardin). The lack of depth gives the design a pronounced vertical thrust.

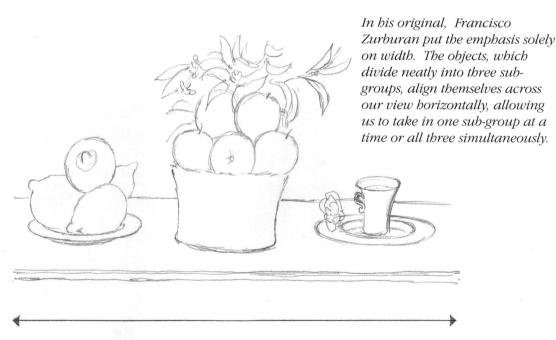

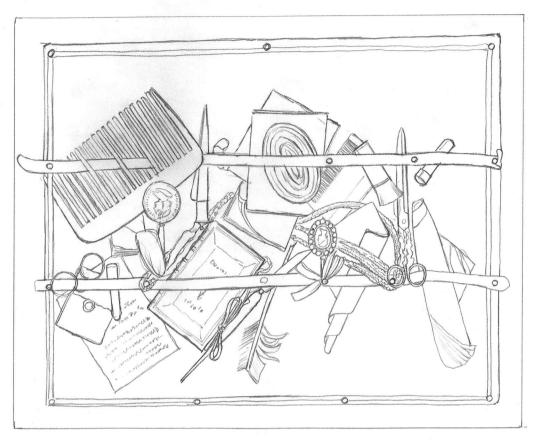

Now for something entirely different, this ime after Samuel van Hoogstraten. This sort of still-life was a great favourite in the 17th and 18th centuries, when it provided both a showcase for an artist's brilliance and a topic of conversation for the bossessor's guests.

Almost all the depth in the picture has been sacrificed to achieve what is known as a 'trompe l'oeil' effect, meaning 'deception of the eye'. The idea was to fix quite flat objects to a pin-board, draw them as precisely as possible and hope to fool people into believing them to be real.

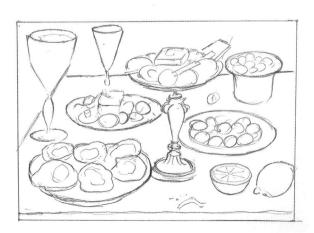

Depth is required to make this kind of arrangement work (after Osias Beert). Our eye is taken into the picture by the effect of the receding table-top, the setting of one plate behind another and the way some of the objects gleam out of the background.

FRAMING

Every arrangement includes an area that surrounds the group of objects you are drawing. How much is included of what lies beyond the principal elements is up to the individual artist and the effect that he or she is trying to achieve. Here, we consider three different 'framings', where varying amounts of space are allowed around the objects.

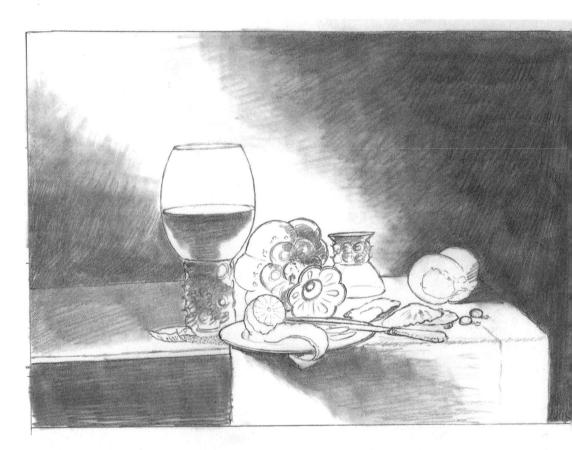

1. A large area of space above the main area, with some to the side and also below the level of the table. This treatment seems to put distance between the viewer and the subject matter.

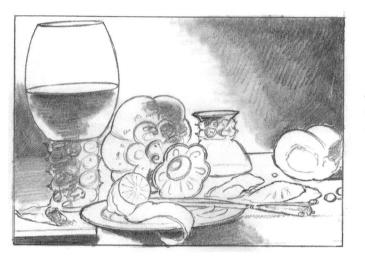

2. The composition is made to look crowded by cropping into the edges of the arrangement.

3. This is the framing actually chosen by the artist, Willem Claesz. The space allowed above and to the ides of the arrangement is ust enough to give an uncluttered view and yet not to much that it gives a sense of the objects being left alienated in the middle of an empty space.

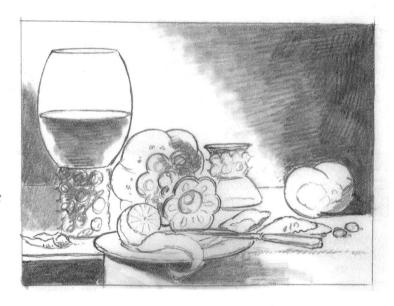

LIGHTING

The quality and nature of the light with which you work will have a large bearing on your finished drawing. A drawing can easily be ruined if you start it in one light and finish it in another. There is no way round this unless you are adept enough to work very quickly or

you set up a fixed light source. In this spread we look at the visual implications of adopting different kinds of lighting, starting with the range of effects that you can obtain by placing a series of objects around a single source of even light.

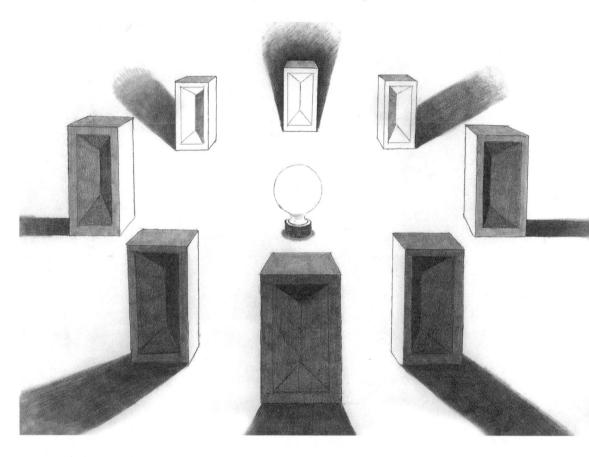

The most interesting point to take from this exercise is how different the same object can look when light shines on it from different positions. Note how the light plays on the surfaces, and how the effects range from a total absence of shadow to complete shadow.

depending on the position of each object in relation to the light. In each case the cast shadow appears to anchor the brick to the surface it is resting on, an effect that is often usefully employed by artists to give atmosphere to their drawings.

Here we show the same three objects arranged in the same way in different lighting versions. Each one also shows the nature of the lighting,

in this case an anglepoise lamp with a strong light which shows the direction that the light is coming from.

These three pots are lit entirely from the front – the light is coming from in front of the artist. The shadows are behind the pots and the impression is of flatter shapes.

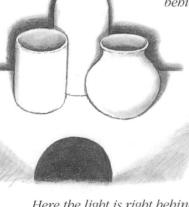

Here the light is right behind the objects. Therefore the pots look dark with slivers of light around the edges. Except for the circle of the lamp the background is dark.

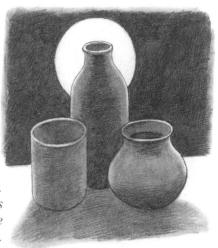

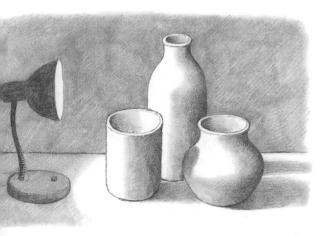

Lighting from above is similar to side lighting but the cast shadows are smaller and the shadow on the pots is, on the whole, less obvious.

Lighting from one side gives the best impression of the three-dimensional quality of the pots. The cast shadows and the areas of shadow on the pots both help to define their roundness.

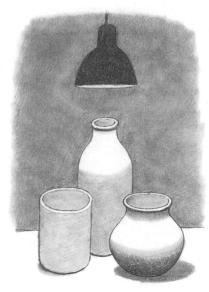

THE EFFECTS OF LIGHT

Many an art student has been put out by the discovery that the natural light falling on his still-life arrangement has changed while he has been drawing and that what he has ended up with is a mish-mash of effects. You need to

be able to control the direction and intensity of the light source you are using until your drawing is finished. If this can't be done with a natural light source, use an artificial lighting set up.

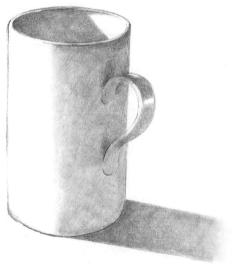

Lit directly from the side; this produces a particular combination of tonal areas, including a clear-cut cast shadow.

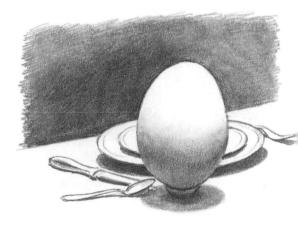

Lit from above; the result is cooler and more dramatic than the first example.

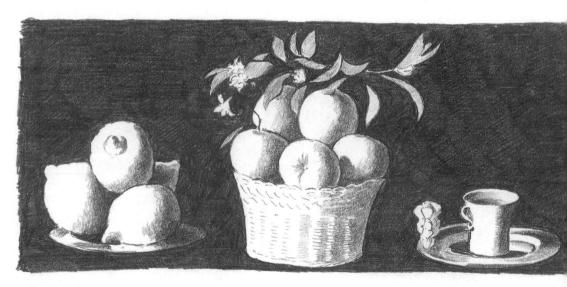

Lit strongly from the side; the strength of the light and the fact that the arrangement is set against such a dark background produces

the effect of spotlighting, attracting our attention to the picture and giving a rather theatrical effect.

A small table lamp lighting a lidded glass jar from directly above. The upper surfaces are very bright. The cast shadows are simple and encircle the bases of both object and lamp. The glass jar catches the light from all around, as ve can see from the small reflections in it. The tarkest areas are behind the light, around the lamp and especially the lampshade.

Directing light from below and to one side is raditionally the way to make objects look a bit odd, unearthly or sinister. Mainly this interpretation is down to our perception; because we are not used to viewing objects lit from below, we find it disturbing when we do. Seen in an ordinary light this cherub's expression looks animated, but lit from below, as were, it appears to have a malign tinge.

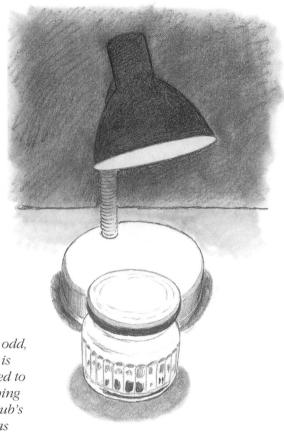

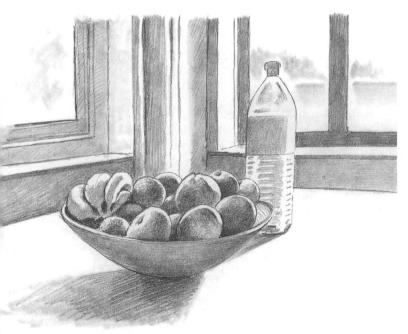

Now a more traditional form of lighting, although still unusual. The bowl of fruit and the bottle of water are backlit from the large windows with the sun relatively low in the sky; I made this sketch in the evening, but you can get a very similar light in early morning. The effect is to make the objects look solid and close to us, but also rather beautiful, because of the bright edges.

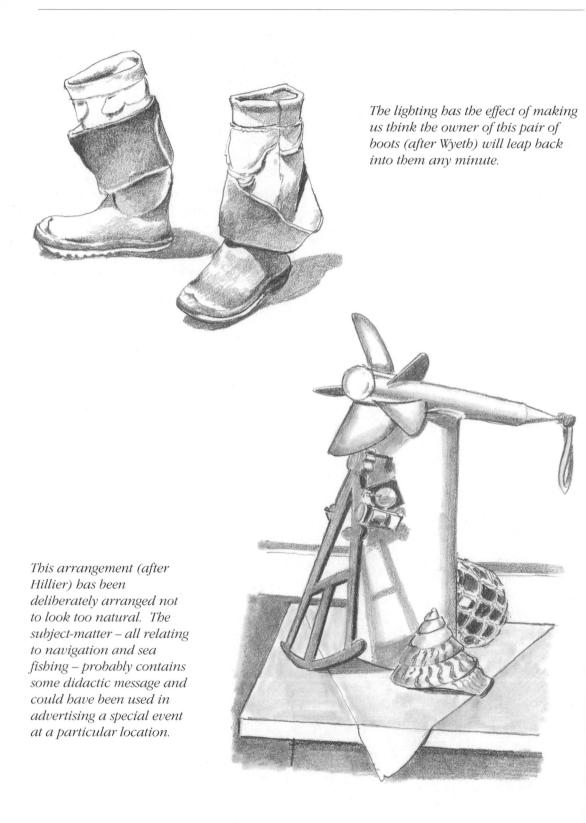

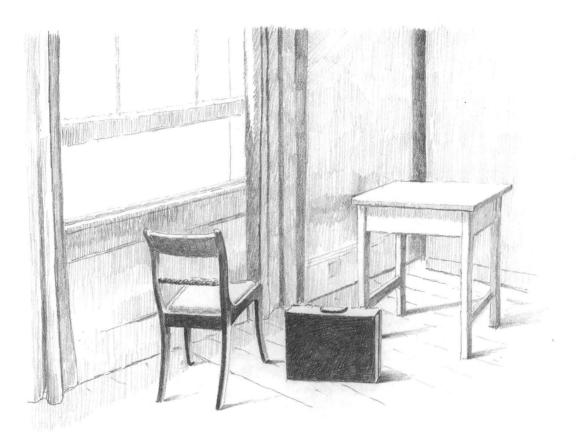

I saw this group of briefcase, chair and table in front of a large open window when I was visiting a school. While the pupils were drawing other things, I had a go at this because the summer sunlight not only

gave a strong structural form to the objects, but also gave a look of a waiting empty room, silent and peaceful. Lighting can often conjure up an atmosphere as well as define space.

MIXING MATERIALS

The first arrangement shown is one of the tests that has traditionally been set for student artists to help them develop their skill at portraying different kinds of materials in one drawing. Such exercises are an excellent means of honing ability. As well as trying this exercise, use your own imagination to devise similar challenges for yourself.

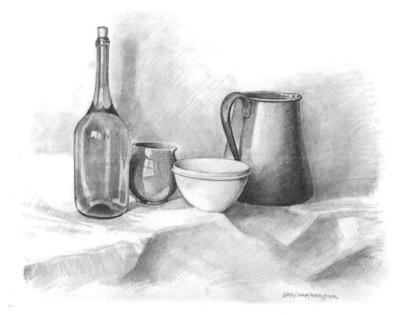

In this still-life group we have a mixture of glass, china, plastic and metal. Note that the glass bottle is filled with water and that the metal jug has an enamelled handle. All the objects are placed on blocks hidden under a soft hessian cloth draped across the background and over the foreground.

This still life after Chardin is of a dead rabbit lying across a game bag on a shelf. The soft furry rabbit, the soft smooth bag and the hard-edged background make a good test.

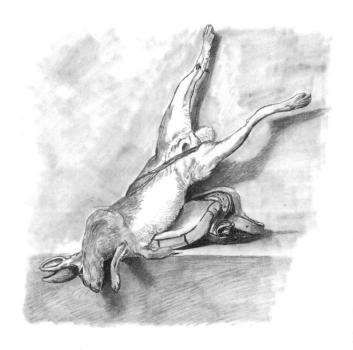

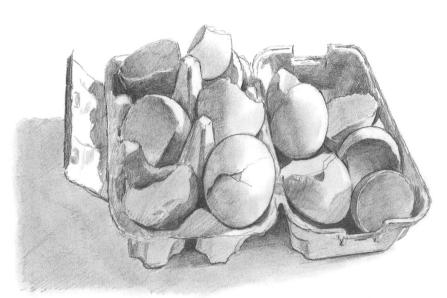

This exercise was quite fortuitous. I came across this egg-box full of broken egg-shells after one of my wife's cooking sessions. She had replaced the broken shells in the box prior to throwing them away. The light on

the fragile shells with their cracks and shadowed hollows made a nice contrast against the papier-maché egg-box; a cruder manufacture with similar use to the subtle natural package.

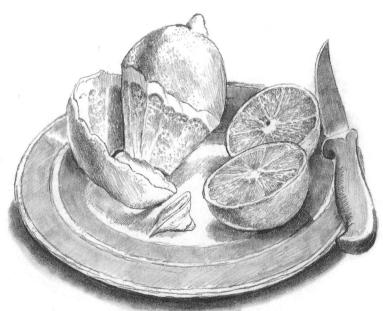

This is an interesting exercise, though it is a fairly difficult one. Here is an orange sliced in half and a partially peeled lemon, the knife resting on the plate beside them. The picture's charm comes from the fact that it is of work in progress, a standard preparation

for a meal or drinks. The real difficulty of this grouping is to get the pulp of the fruit to look texturally different from the peel. The careful drawing of contrasting marks helps to give an effect of the juice-laden flesh of the orange and lemon.

Themes and Composition

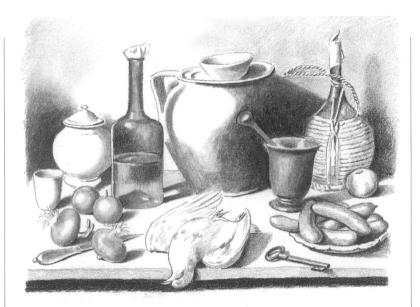

HEN STILL LIFE BECOMES MORE PRACTICAL, it is time to start considering what sort of still-life picture you want to draw. Of course there are many ways of approaching the composition of this kind of subject, but often the most interesting one is to take a theme to work on. Of all the objects most people have around them in their homes, some of the most obviously suitable in terms of contrast of shape and texture are the everyday things connected with eating, including food, utensils, crockery and cutlery. These can be turned into a theme quite easily, taking the idea of the preparation of a meal. Another theme concerned with eating and drinking might be the table laid and the meal begun, so that food, glasses, dishes, cutlery and so on are naturally placed, as they would be during a meal.

So one obvious theme is food and drink and connected with that is the preparation of food for cooking and the layout of a table or picnic showing the various dishes in an appetizing way.

Any such day-to-day activity can become your theme. Getting dressed, for example, could be shown by an array of clothes half-folded, half-strewn across chairs or bed, or hanging on doors or chairbacks.

In this way you can go on devising schemes where you limit the array of objects so that they all adhere to one themed idea, giving a narrative element to your picture. You could also arrange a series of pictures depicting various stages of an activity, which would help to create interest in the dynamics of life, seen through the display of objects.

Many of the old masters produced still-life pictures that can be taken simply at face value, but they very often also contain a background symbolism that would more easily have revealed its meaning to the onlookers of the day, when symbolism was more commonly used to carry a message in the absence of mass literacy.

All the normal activities of everyday existence tend to have objects that relate to them and can therefore represent them. Grouping these objects together reminds people of the activity and so there will be an immediate emotional response in the onlooker as a result of the association of ideas. Your themes can be worked out from the activities you are particularly interested in, such as sports, hospitality, trade or hobbies.

Start with things you know most about, as you will be familiar with the forms of the objects and will invest them with your own emotional response. Then, once you have completed two or three of these types of still-life compositions, have a go at ones that you are less familiar with. It all adds specific interest to your pictures, both for you and the person who views them.

FOOD AND DRINK

We start with a popular form of still-life drawing – food and drink. The traditional pictures of this subject often show food ready

for the preparation of a meal, rather than the completed dish. This has the effect of creating a more dynamic picture.

Our first picture is of a classic 17th-century still life, by the Italian artist Carlo Magini (1720–1806), of bottles of wine, oil pots, a pestle and mortar and the raw ingredients of onions, tomatoes, pigeon and sausages. This is a very traditional picture of the basic preparation for some dish. Note the balance achieved between the man-made objects and the vegetables, bird and sausages. The hardware is towards the back of the kitchen table and the food is in the front.

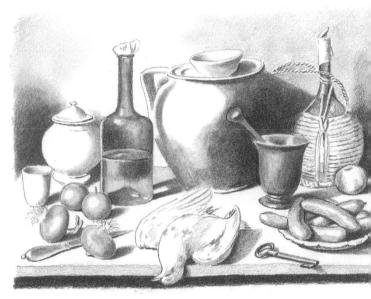

The still life by Italian artist Filippo de Pisis (1896–1956) is simpler and is drawn in a looser, more impressionistic way. Here the intention of a 20th-century artist is to create a feeling of light glancing off the ingredients of an arrangement of apples and a melon slice.

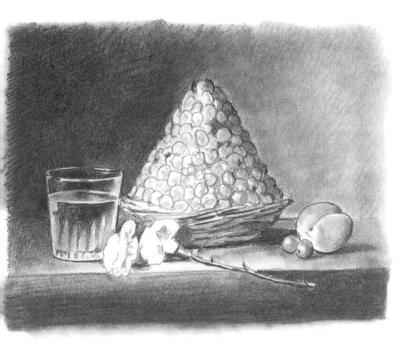

Next we look at a very simple picture by that master of French still life Chardin (1699–1779), who was so renowned in his own lifetime that many collectors bought his works rather than the more complex figure compositions by the artists of the Paris Salon. This picture shows fruit, water and a flower. The heap of strawberries on a basket is unusual as a centrepiece and the glass of water and the flower lend a sensitive purity to the picture.

This is an accidental still life come upon by chance in my own kitchen, where a few apples but down on a marble slab were backed by a bottle of water, a bottle of wine and a roll of kitchen towel. The formality of the composition caught my eye and I drew it quickly before it became disarranged.

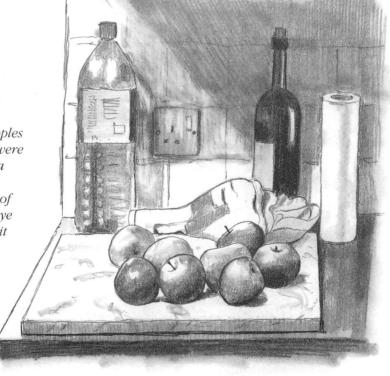

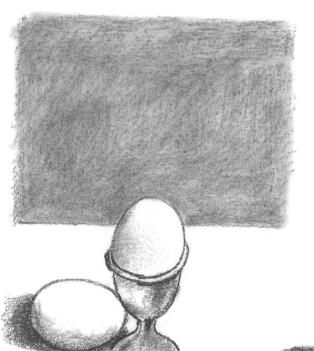

This very simple example by the Italian artist Renato Guttuso (1912–1987) shows just two eggs and an egg cup. The arrangement of the eggs on a surface with the curve of the egg in the eggcup jutting up into the background tone of the far wall makes a very abstract and tightly perfect design.

This second piece by Guttuso shows a tin can, a packet of cigarettes and an egg in a fragment of pottery dish. The rather unorganized composition has an accidental look, although it might in fact have been carefully arranged.

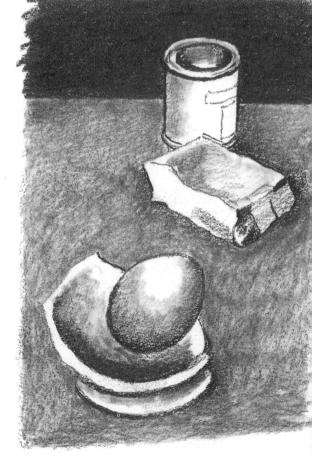

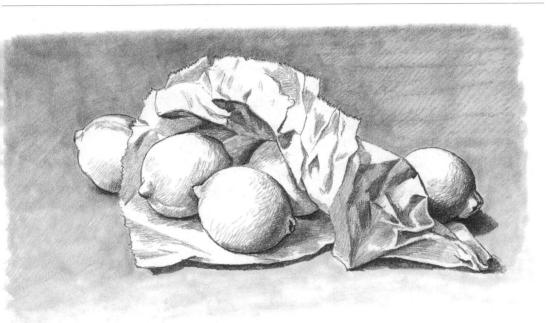

This picture of a few lemons spilled out of a crumpled paper bag has a simplicity and elegance that the British artist Eliot Hodgkin (1905–87) has caught well. Again it looks

quite a random arrangement but may well bave been carefully placed to get the right effect. Whichever the case may be, it is a very satisfying, simple composition.

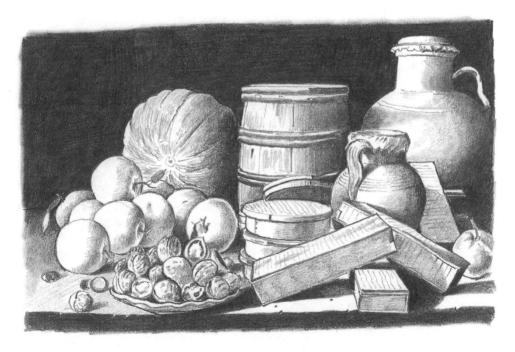

Conversely, this beautiful piece by the famous Spanish artist Luiz Meléndez (1716–80) is a full and even crowded arrangement, but because of its simple workaday subject

matter gives a very solid and completelooking group of objects. The pots, packets and loose fruits and nuts both contrast and barmonize with each other at the same time.

This sketch of another still life by Spanish artist Juan Van der Hamen y Leon (1596–1631) is much more carefully composed and gives a formality to the composition. The placing of the pots, baskets, plates and packages could not be accidental; it is well prepared and thought out. This formal arrangement creates an almost abstract, spatial quality to the composition.

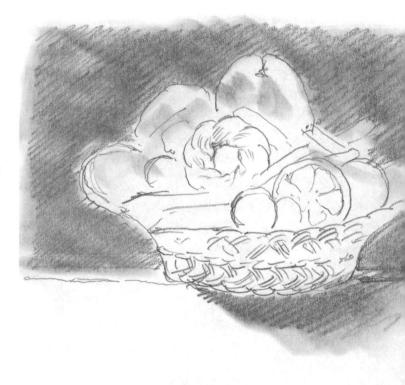

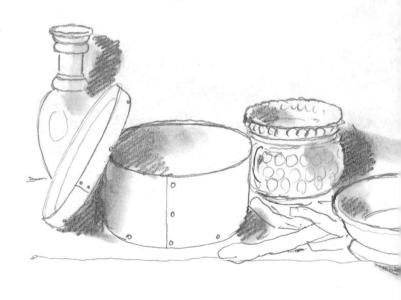

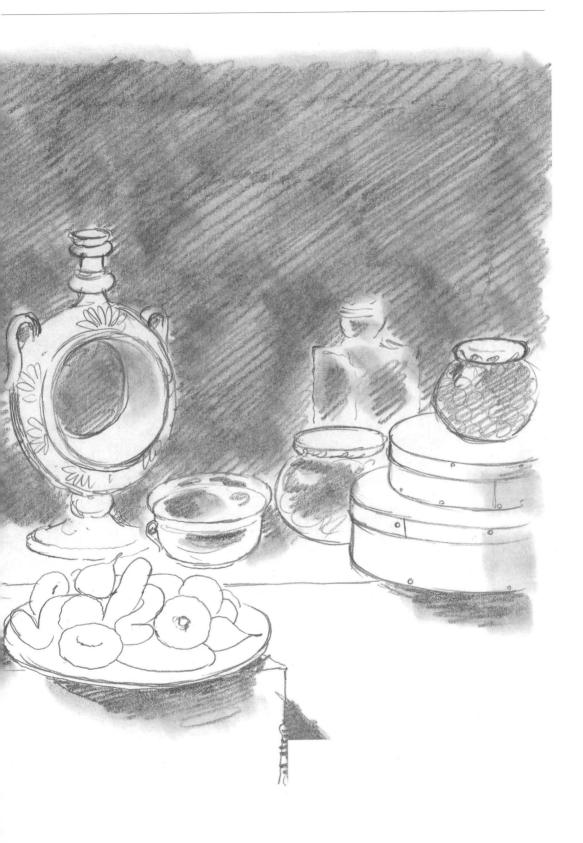

This artless but carefully placed group of eggs and vegetables by Eliot Hodgkin almost has the quality of an illustration for a cookery book. It is a simple but effective treatment for a horizontally biased composition.

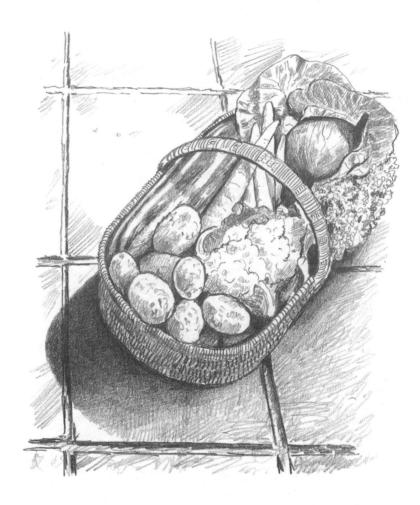

An apparently casual arrangement of a basket of vegetables on a tiled floor turns out to be not so casual when you study the disparate shapes of the vegetables, which must have been chosen in order to make a good picture. These two arrangements are examples of painters' ways of taking a still-life composition and treating it in such a way that the subject matter is no longer of any importance.

Here the view of the space and the way the shapes combine produces a feeling of gentle, airy space, formalized in an almost abstract way.

The Russian garden table (after Ardimasov) with the remains of refreshments and a magnificent bowl of flowers is really most important for the impression of space and light that the composition evokes. The actual objects are necessary but are not in themselves important; they just help to limit the parts of the space in an elegant way that produces a satisfying atmosphere.

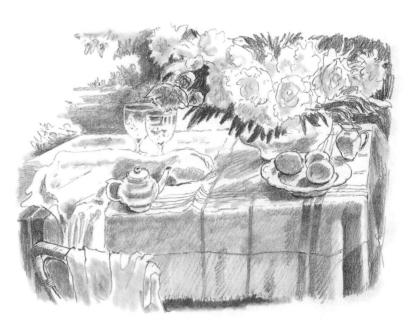

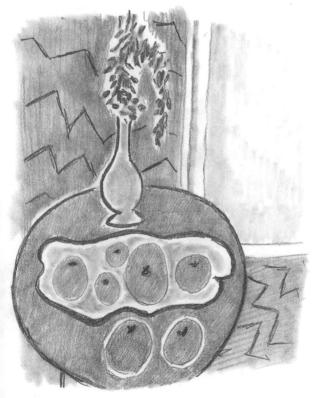

This still life after Henri Matisse (1869–1954) is even more arbitrary about the way it uses the shapes of the fruit and flowers. These shapes are important, but not because of their actual substance; Matisse's interest was in the way they create a pattern across the table, which is drawn tilted up towards our gaze. The whole set of shapes creates a very formal pattern, defining the area aesthetically but taking very little notice of the meaning of food or flowers.

TRAVEL THEMES

These examples of the theme of travelling take two moments in time. The first is before the journey starts and the second is at the time of return when unpacking begins, showing not only clothes but also souvenirs and presents. Together they bracket the travelling experience.

The arrangement of two suitcases accompanied by a hat, umbrella, coat and boots gives an idea of someone about to leave on holiday. It is a compact composition and relies on the solidity of the cases to act as the framework for whatever else is placed with them. The suitcases make the statement but the accessories give a season to the theme.

In this second sketch on a travel theme the case is opened and suggests its owner has come back from somewhere interesting or even exotic. The clothes are half revealed in the case and the packages carelessly spilled around, with souvenirs of statuettes,

dolls, bottles, travel guides and presents giving a narrative element of someone returning from abroad. Obviously this theme could be adjusted for any country or continent to suit it to the person commissioning the picture.

MUSIC THEMES

Musical themes have always been very popular, usually shown by the casual deployment of musical

instruments, musical scores and so forth across a table, chairs or the floor.

A musical still life was a very popular theme in the 17th and 18th century. This one, after Baschens, is rather arbitrary but works mostly because the shapes of the instruments are so interesting that it almost doesn't matter how they are arranged. The great beauty of this sort of theme is that you can't really produce a bad picture if the objects themselves are so satisfying to look at.

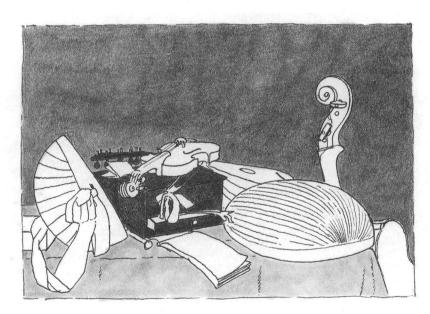

I've shown this group of instruments depicting a musical theme in simple outline forms to classify the dramatic possibilities of rounded, flattened and cuboid forms contrasted with each other. Notice how all the objects are mostly heaped in the lower half of the composition, contrasting with the blank

space above. The rounded shapes of the lutes, the flatter angularity of the violin and bass, the open music score and the cubic black box which presumably holds music paper, pens and ink create a variety of clearly defined shapes, which in a way mirrors the musical possibilities of contrast and harmony.

PAPER AND BOOKS

A theme of paper and books was very popular in the 18th century. Images of books, packages or rolls of paper and envelopes were used to create a very specific type of picture, which suggested a literary or business style of life.

This interest in books was part of life for the enlightened members of civilized society at this period, and of course this was a time when the production of printed works on paper had become a significant key to the dissemination of literature and art, in the form of texts, etchings and prints. Consequently, anyone who was anyone in society would draw attention to their interest in literary production by commissioning pictures that echoed this idea. The artists producing them were also keen to shown off their technical expertise in showing paper as a textural object.

The neatly tied bundle of paper in the background suggests a setting for legal documents

or business papers of some sort, spread across a desk waiting for attention.

The rather battered-looking books give a more literary look. These well-used tomes

imply a close connection with the importance of the written word.

This composition showing shelves of music books again refers to a musical theme, but this time has a more scholarly

look because this is where the composer is working to produce the raw material that instruments will eventually play.

THE SEA

These pictures, redolent of life lived close to the sea, bring the atmosphere of the ocean into a piece of still life. The first is a collection of things found on the beach and the second is an arrangement of nautical instruments that points out the interests of the person who commissioned it. The third, more simple in composition, relies on shells for its message.

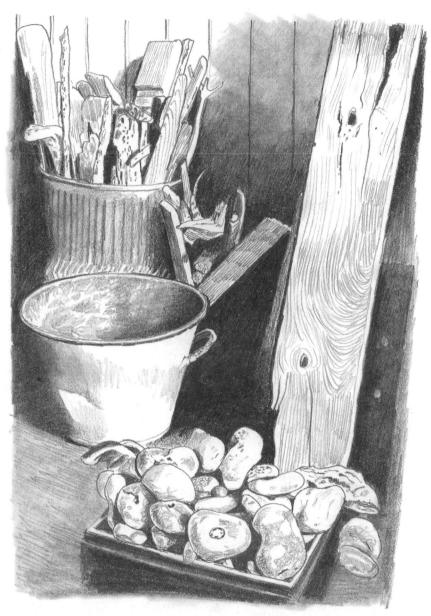

This still life hints at the outdoors, with its piles of driftwood and box of large stones. It gives the impression of a corner of the garden shed, with the collected minerals and wood shoved into battered pails and dustbins. The effect of worn wood and stones brings home the idea of time passing, with the wearing down of natural objects by natural forces. There is a strong suggestion of the sea, even though we can't see it anywhere.

The next picture, after British artist Edward Wadsworth (1889–1949) is a deliberate effort to bring the world of boats and the sea into a symbolic composition which is almost

monumental. The objects work as abstract shapes and textures and it is only after noting the satisfying arrangement that the theme of the sea comes across strongly.

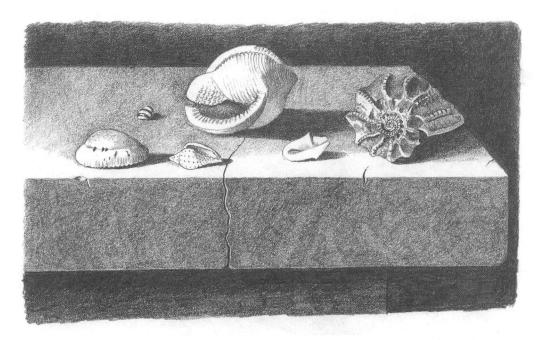

In the still life of seashells on a shelf by Adrian Coorte (1685–1723), the sea is nowhere to be seen. The elegant beauty of

these sea creatures' exo-skeletons makes an attractive picture in its own right, apart from the pleasing connotations of the ocean.

SYMBOLISM

Many of the still life pictures that were painted during the 16th and 17th centuries were careful arrangements of symbolic objects, designed to tell some sort of story about the commissioner or to point out a particular moral to the onlooker.

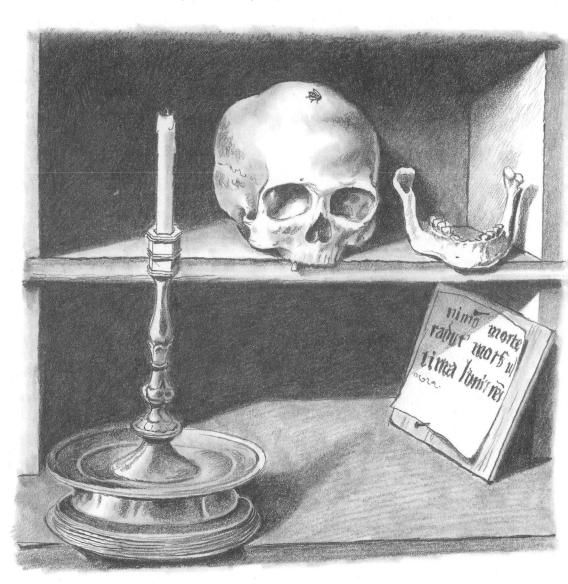

The most obviously symbolic pictures that were produced in the still-life genre were often concerned with the passing of time and approach of death. This still life after Bruyn the Elder (1493–1555) is a simple but effective

composition with its blown-out candle, the skull with its jaw removed to one side and the note of memento mori on the lower shelf. The dark shadows under the shelf set the objects forward and give them more significance.

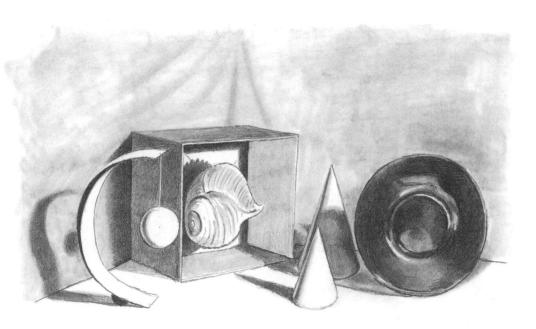

This symbolic still life of the present day is a very carefully arranged set of objects with some held in space by thin cords. The box has a shell suspended in it and the translucent plate with the two cones creates an

enigmatic but obviously symbolic geometry of shapes. Daniel Wright, who produced this, became an architect soon afterwards and you can see the delight that he takes in defining spaces in a formal way.

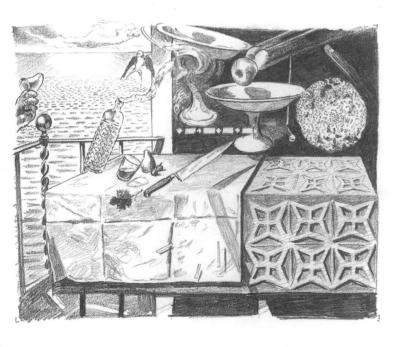

Salvador Dali's Fast Moving shows another kind of picture where all the ingredients are the same as in a normal still life, but somehow nothing here looks still. He draws the items which would normally repose on the surface of the table floating above it in a sort of dance. One can imagine that Dali laid the objects upon the table and just elevated them to give the effect of a truly mobile still life.

AN OBSESSION WITH A THEME

Some artists are famous for producing still-life pictures that repeat the same theme over and over again. The Italian artist Giorgio Morandi (1890–1964) spent the majority of his

working life making pictures of pots, bottles and similar ordinary objects of mostly vertical shape, all grouped together against a plain background.

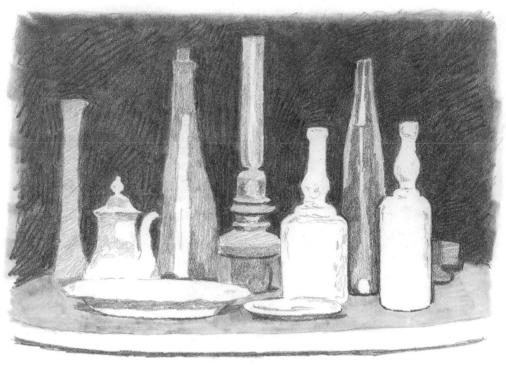

Here we have a large group of bottles and pots against a dark background with a couple of plates in the foreground. This

monumental still life suggests much bigger objects but still has the same constituents that Morandi always used.

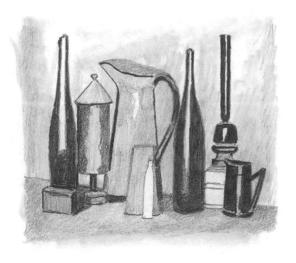

This Morandi is similar in theme, with the addition of jugs and other items, this time against a paler background.

This even simpler Morandi group has just one bottle and a couple of boxes, in pale ones on a pale background. All his bictures were very similar in theme and appearance and he seemed to be exploring the depths of the simple still-life composition. Most art critics now think that he achieved an almost metaphysical presence in his work

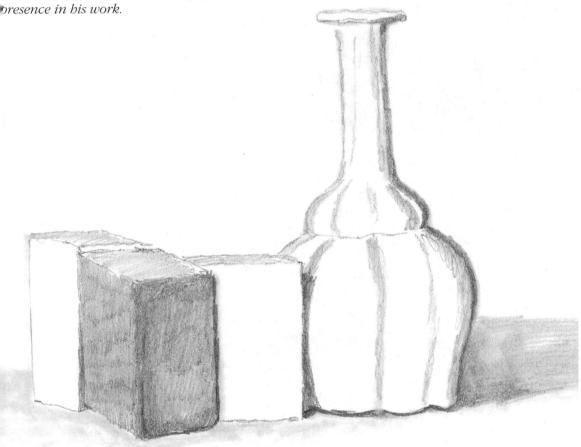

USING DIFFERENT MEDIA

Now, looking at a still-life arrangement of some objects gathered together in a Morandi-like arrangement, let us try out different methods of expression in different mediums.

Here we have a group of precious objects from Persian civilization arranged in a simple composition. The group does not have a great deal of depth and is set on a well-lit surface against a dark background. I've tried it out in two ordinary media: pencil and brush and wash, for which you can use either ink or watercolour. The arrangement remains the same but, as you can see, the change of medium creates a different look.

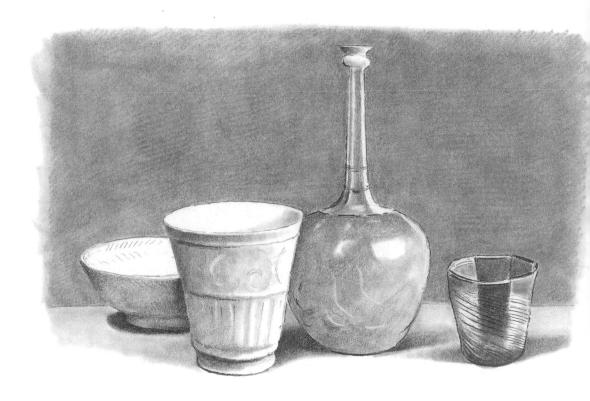

First, a fairly soft pencil (2B) gave me clearly defined edges and grey tones, producing an effect of light and shade and textural surfaces such as glass, porcelain and so on.

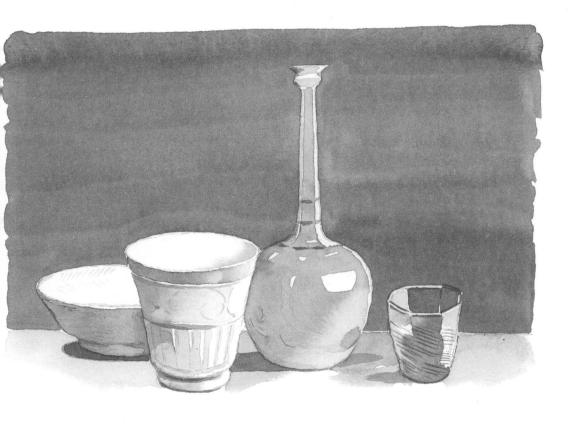

In this watercolour version of the same composition, grey tones have been washed on in large areas. This doesn't give quite the same surface effect as pencil, but is a more dynamic medium that creates an instant

attraction. Both versions rely on fairly accurate outlines to start with. In this example you can see how the same picture can be made to look very different simply by a change of medium.

FLOWERS

One of the most popular themes of all time in still-life pictures has been those depictions of flowers in vases which remind people of their own homes. The simple, delicate beauty of the blossoms, combined with an attractive container, can be handled in many ways to convey their growth and fragrance.

This theme is one of the oldest of all, with many of the early Flemish and Dutch still-life pieces being abundant arrangements of flowers painted with almost botanical precision. However, since the time of the Impressionists the theme has moved on to more loosely painted pictures of great tactile beauty.

British painter and printmaker Craigie
Aitchison (1926–) produces pictures of plants
in vases which reduce everything to the
minimum form for maximum effect. His lonely
vulnerable flowers held in an elegant but much
sturdier container are centrally placed and
have the simplicity of a child's drawing, but
with a sort of heightened significance. The
notably simple approach with usually plenty
of space around the object makes it look
very important.

The vase of flowers by the master Chardin has both delicacy and strength, with rather the same effect as the Aitchison piece but with more depth and structural complexity.

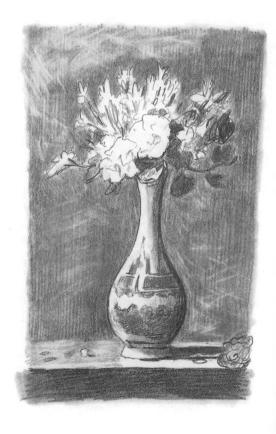

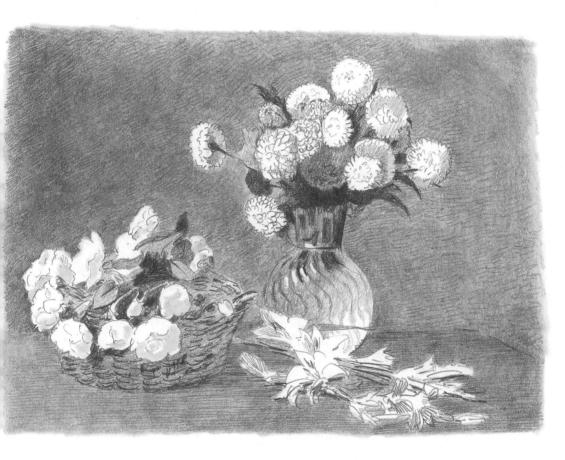

The rich bunches of dahlias in this picture after Henri Fantin-Latour (1836–1904) have an almost tactile feeling of the creamy plush blossoms. They are lit with a soft light against a shadowy background that helps to produce a strong effect of depth and texture. Fantin-Latour's flower paintings are some of the most admired in the genre.

UNUSUAL COMBINATIONS

Here we look at less usual types of composition where we take something which is not usually considered to be an aesthetically pleasing object, but which, when drawn well and clearly defined, nevertheless produces an interesting result.

With clean laundry of towels, bathmats and tea towels piled neatly on the seat, this ordinary kitchen chair from the last century is as square and simple as is possible. The simple, flat wall background, and the fact that the whole scene is lit sharply with very little light and shade, produces a strong, plain image.

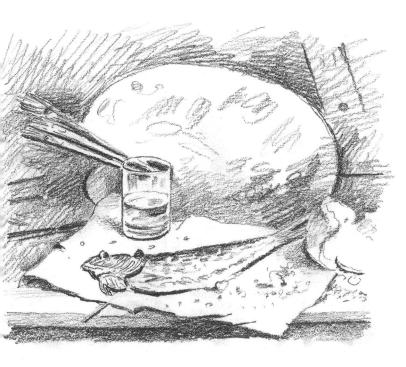

This artistic theme is rather complicated by the fish in the foreground. As the fish is not cooked it cannot be linked with a meal, so the picture must be concerned with an artist's palette and brushes together with items from a still life that is to be painted.

This group of stuffed dolls and teddies with a couple of books seems as though they might be on a nursery shelf. Perhaps they are old toys that a girl grown into a woman has refused to part with because of their sentimental value.

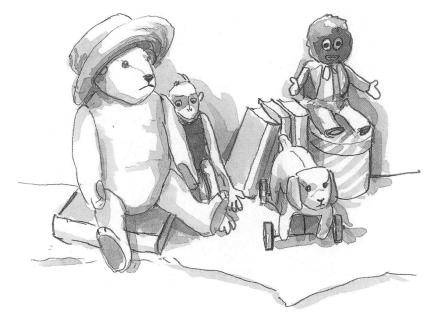

This is another uncompromising and rather unlikely composition of a group of toilet rolls stacked almost as in a supermarket. The dark background and arrangement, rather like a monolithic structure, gives these bumble articles a dramatic image. Unlikely objects are often effective if used in this massed way, rendering them more significant than the way in which they are usually seen.

ORMAL INFORMAL

The final example shows a naturally informal arrangement. By using a formal, mannered

approach in the painting of it, the artist has created a completely new interest.

This very decorative still life by Spanish artist oan Miró (1893–1983) has an informal look nut is presented in a very formalized, patternike way that produces a very interesting, almost geometrical set of shapes and spaces.

The pattern of the wood grain is as important in its texture as is the spotted art folio, the decorated jug, the masthead of the newspaper, the strongly diagonal walking stick and the soft, writhing look of the empty glove.

Expanding the View

HEN WE CONSIDER STILL-LIFE PICTURES we are mainly concerned with quite closely knit, tightly controlled areas in which the required objects are gathered together to produce an attractive composition. Even when the pictures themselves are large they often show a fairly constricted area, so sometimes it is a relief to both the artist and the viewer alike to find a still-life picture that pushes back the boundaries of this genre a bit and can even take in the outdoor world beyond the confines of an interior space.

There are many examples of this type of picture, though they didn't always fit entirely into the still-life genre. Many of the earlier works of art of this nature included individuals or groups of people and, because they had some sort of narrative, were not exclusively still lifes. Then, as the genre became more defined in the art world, still lifes tended to become more and more enclosed in their settings. However, after the 19th century got under way artists looked for newer ways to express their concepts and so we begin to see still -ife pictures which take us out into the open air.

The most obvious transition towards this is in those paintings where a still-life arrangement is shown in front of a door or window which gives a view out onto the world at large, and so suggests much larger spaces in the picture. Then artists began to use the open-air venue more adventurously and placed the whole setting outside, which greatly expanded the range of the still-life painter.

The use of mirrors and reflections which open up a parallel world within the picture was an interesting development, and when the world of outdoor leisure pursuits became a popular part of everyday activity, the scene grew very much wider. The group of objects on the beach left by the people swimming; the pieces of luggage grouped by a car or on a platform; and the rucksacks, boots and gear of the climber outside a tent or mountain hut all contributed to the growing expansion of the humble still-life picture.

So now we shall look at some still lifes that bring in a wider world, either by suggestion or else by actually giving you a view out into it. Some of the drawings shown in this section include parts of the landscape, though not in a way that makes them qualify as landscape pictures; instead they remain still lifes, but with added background. By studying these we shall explore ways of opening out the simple still-life composition into something that draws our attention to areas beyond the limit of the picture itself.

APERTURES

Larger still-life compositions are frequently associated with apertures such as arches,

doors or windows. Here we show a few interesting examples of this type of still life.

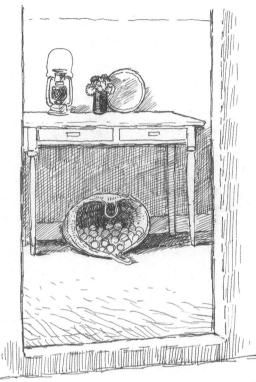

This illustration is a view through an arch from one room into another. Against the far wall, framed in the doorway, is a table with a couple of objects on it. Under the table is a large basket on its side, full of apples or some similar fruit. The very fact of this all being framed in a doorway gives a spatial awareness of the room beyond and the room that the viewer is standing in.

Another view, this time of a South African village but in which the day-to-day utensils are all set out on and under a kitchen table or hanging on nails on the wall, also giving an impression of a space big enough for the viewer to be standing in. The simple but polished kitchen utensils make a beautiful formal pattern depicting a disciplined but simple life style.

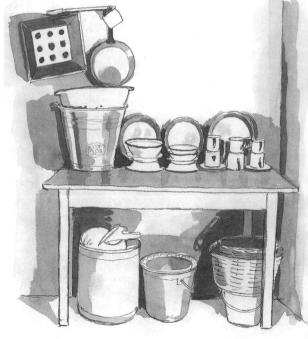

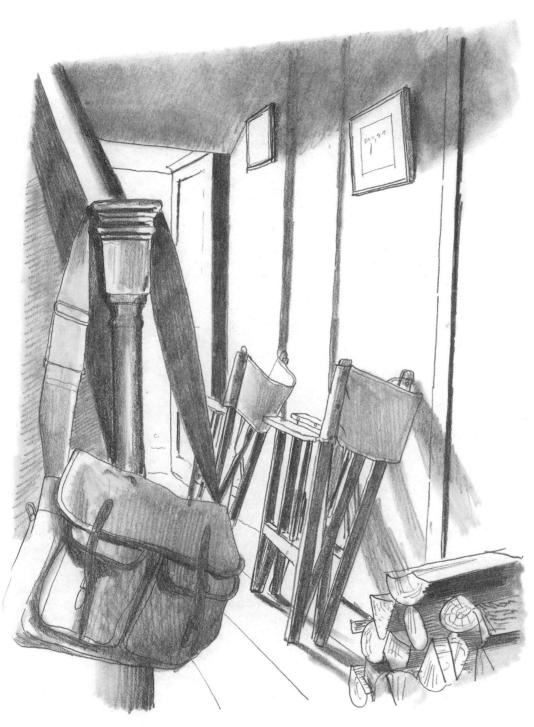

This more accidental view is of a hall corridor towards an open garden door which allows light to flood into the space, outlining the deckchairs leaning against the way, the pile of logs and the satchel casually

swung over the newel post of the staircase. The sense of space beyond the immediate view and also probably behind it and up the staircase is well caught in this casual composition.

SUGGESTING LARGER SPACES

Sometimes the space does not have to be spelt out, as the inference in the subject matter is of larger spaces even if they are not directly seen in the picture. The outer world may be just suggested by light or the presence of a window, which immediately reduces the closed-in effect that still life can often have. Although the subject is contained it doesn't have a final boundary, as the space stretches beyond the view in some way.

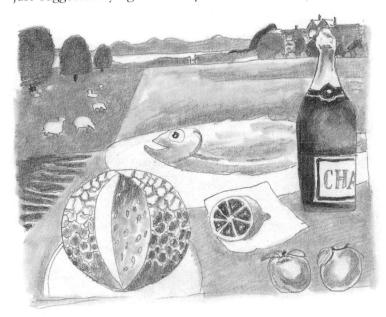

Placing a still life on a picnic cloth on the grass or on a table in a garden quickly pushes away the boundaries normally associated with the still-life composition. The suggestion in Prunella Clough's Picnic at Glyndebourne is of a formal meal taking place in the engaging setting of a manor house. The distant landscape behind the formalized pattern-like shapes of the picnic gives tranquillity to the scene.

The tree trunks creating an informal avenue in a Mediterranean billside garden and the tabletop with the wine, vegetables and discarded book suggest sunny days in the open air.

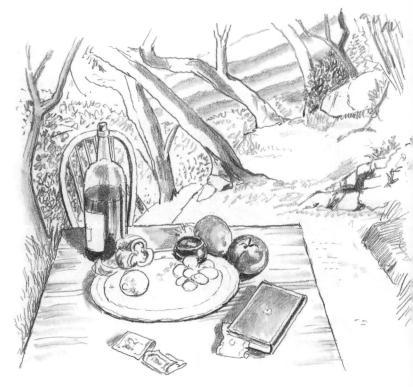

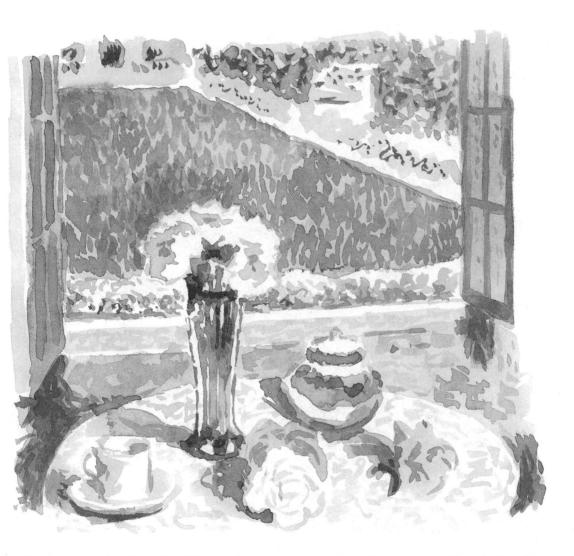

In this drawing after Henri Le Sidaner, the placing of a table laid for tea in front of a window looking out onto a lawn takes the

view out into the open air although the still life is itself in an enclosed area. The flowers on the table link it with the garden beyond.

A lone chair by a desk lit by strong sunlight from an invisible window in the corner of a room is very effective in giving some impression of a larger space behind the viewer. Here Danish painter Peter Ilsted creates a natural and expansive still life.

In this pen drawing, the vase of flowers on a small table is tucked into one side of the composition, exposing the large basketwork chair. The windows and curtains beyond also suggest an area of space, which is not seen but inferred. How big the rest of the room may be is not clear but the impression gives plenty of spatial depth.

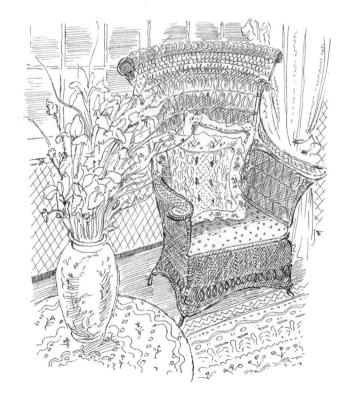

This still life is very clearly referring to a large expanse, because here the only object is a loaded hay cart, obviously in a farmyard. The buildings around are hardly suggested but the associations of the subject matter encourage

us to accept that the area around and about is quite large. The same would be true of any sizable wheeled vehicle. Try this out with a car by the kerb, which in turn suggests the whole street.

SUGGESTIONS OF THE OUTSIDE WORLD

All these views of spaces beyond the actual still life include a suggestion that the still-life subject itself is just a natural interior, which is part of someone's life style and hasn't been arranged or composed. In fact, the artist of course has to

choose his viewpoint carefully and decide the edges of the picture to create a compositional whole – so although the scene appears almost accidental, the reality is that a great deal of artistic consideration has gone into the picture.

This view of an unmade bed under an open window with flowers and tea things in the foreground corner creates an immediate idea of early-morning leisure on a summer weekend. The impression of the season comes from the flowers and the open window, while the tea by the bedside suggests that the occupants of the bed had no need to get up quickly. Also, the pulled-back covers imply that they are in no hurry to remake it and are probably talking or doing other things close by. This is a very atmospheric picture.

A rather empty space at the bottom of the stairs leading to the front or back door of a house provides a dramatic setting for this lone chair caught in the strong light from the window behind it. The inclusion of one strongly lit object is a clever device to give a tactile notion of space in a picture. It also creates an impression of more space behind the viewer, around the corner and through the window.

An even larger space looking out through windows typifies Andrew Wyeth's picture of a milking room in an outbuilding of a New England farm. The care with which he has depicted the shiny milking pail, the old tin cup on the piece of wood and the spigot from

which a stream of water pours into the worn stone sink and then drains over the edge gives an intimate picture of a piece of country life. It is simple, spacious and strongly redolent of hard, old-fashioned farm work.

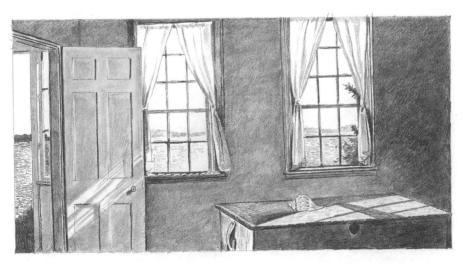

Also after Wyeth is this composition of a room with large windows and an open door leading to the sea, with the seashell on the top of the large wooden chest emphasizing the location. Again the emptiness of the room

gives spacious qualities to a very simple but elegant still-life statement. This is a fine example of how the genre frequently suggests the movement of life which is stilled just at this minute.

MOVING FROM INSIDE TO OUTSIDE

Once more we look at a Wyeth picture of a view from a room, but this time the simplicity of the still life on the table is almost overwhelmed by the interest of the landscape outside, with its sawn logs, wire fencing and distant trees.

Now we have moved right outside and are looking in a window in an old-fashioned sweet shop, where all the goods are displayed in the open-shuttered window space. The sense is that the viewer is outside looking at a partly interior and partly exterior still life, the window frame and its appurtenances being very much part of the picture.

Still outside, but now in the garden, this composition shows a secluded corner in front of a window with potted plants on a decking

surface. The wrought iron table and chairs complete the feeling of intimacy, though we are also aware of the space beyond.

OUT IN THE WIDER WORLD

Now the outdoor scene is of unlimited space, and our subject is a still life of a larger nature: a sailing boat beached in a field close to the sea, another brilliant evocation by Wyeth. The uninterrupted view of the horizon is clearly pointing to a much larger world.

This is another obvious example of the large outdoor still-life subject. Like the haycart seen earlier, this machine takes the subject matter out of the house and also gives the artist a really sizable object to depict. The main thing is to find an angle to draw it from that will show the automobile in an interesting way

and also provide reflections that are interesting to draw. Here, the reflections are seen in the simplest possible way, which is why I chose this angle. In any other view the reflections got very complicated, and I thought that these rather more simple effects would give more solidity to the car.

This is another still life with maritime connotations, though it could be any arrangement of machinery or industrial details that is the subject here. The drawing is of the upper deck of a 1920s steamship with its clutter of objects, which are all entirely functional in nature. This really is an

enormous piece of still-life drawing and these larger pieces we have looked at almost cross over into the area of landscape. However, I think they can still be classified as still life because they are in enough detail to make the objects the subject of the picture rather than the suggestion of larger spaces.

Varying Techniques and Materials

ERE WE COME TO A SECTION WHICH IS ALL about looking at the various techniques that we can use to produce our still-life drawing. Obviously, the still-life composition can be drawn with anything, but sometimes a particular type of arrangement comes across as more interesting drawn in one medium than another. Not only that, you may also use a different technique when handling the medium, which will also add to the final effect. This is a trial and error situation, because it is not possible to know for sure which technique and medium will work the best until you have tried them out. When you have more experience, you will have a better feel for which technique will enhance the still life you have in mind. There is no substitute for experience in this respect, because even if

theoretically you know which way of drawing is supposed to be the best in a particular situation, your own expertise has a lot to do with the final result, and you may be more proficient in one than another. So go ahead and experiment; try out as many new ways of drawing as you can discover, and you may be even lucky enough to come up with a completely new method that hasn't been found before. This is perhaps a bit unlikely, since there has been so much done in art in the past five thousand years, but nevertheless there is always a possibility. Keep an open mind as to how you should work.

So we shall proceed through all the well-known methods, looking at some of the varieties of ways of working that are available even within just one technique. Try each at least once to see if they interest you enough for you to persevere and master them.

We shall look at drawing in pencil, in ink and in chalk, as well as using a brush and tonal wash of ink or paint. We shall also try putting several methods together as mixed media. Although there are tried and tested ways of doing all this drawing, there are no rules that cannot be broken by the adventurous artist. This often is the way that you learn. You will find that the process of using different materials and techniques will first of all be very interesting, and secondly will ensure that you have some experience of these methods, which is where you begin to find your own favourite ways of drawing.

I found that when I was learning to draw and paint I would get very hung up on a particular way of drawing for some length of time, which made me quite expert in it. Having learnt to use a certain technique or material well, you can then go on to see how another method may work and the experience you have already had will help you to experiment anew.

PENCIL DRAWING

The first thing we look at is the basic use of pencil to produce your still-life drawing. A drawing can function in several ways: as a sketch that acts as a preliminary stage for a

painting, as an underdrawing on top of which you then put colour, as a finished piece in itself, or just as a piece of information to use for later work.

To start with, try out this loose-line technique, in which there is very little in the way of careful tone or sometimes none at all. The questing, wobbling line, which almost looks as though the point of the pencil never leaves the paper, is a very expressive medium for quickly and elegantly stating the form of the objects it is describing.

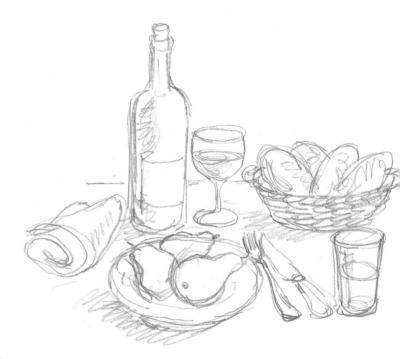

Notice how the line varies from one side of an object to the other, sometimes heavy and bold, sometimes slight and varying. To help this transition in definition you have to hold the pencil loosely as shown, more like a wand than a fountain pen. This of course takes a bit of practice but it is amazing how quickly the method can be mastered.

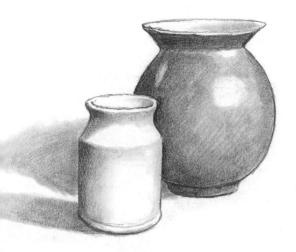

Shown here is the more careful and deliberate method of drawing quite fine and precise outlines and then carefully shading in the tone until it graduates from dark to light with great subtlety. For this method, the pencil has to be kept finely sharpened at the start, but allowed to become softly blunt when shading.

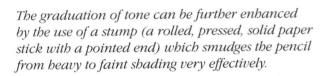

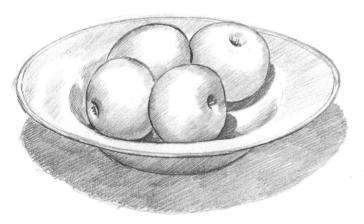

Another, even more classical approach, is to draw similar clear, sharp outlines and then use a diagonal hatching system of closely drawn lines which build up large areas of tone very effectively and which, with just a change in pressure increase the depth of tone. Leonardo da Vinci was a great exponent of

this system of hatching, which he apparently did with great speed and precision. It may take you a bit longer than him and you may not have his brilliant control of the pencil, but you will learn by practice. The hatched lines are drawn only in one direction, and the results are very attractive.

PEN AND INK

Now we move on to pen and ink. There are many types of pen that you can use. The techno graphic pens with fine fibre tips produce lines of uniform thickness and weight. If you use these you will sometimes need more than one calibre, or thickness. Then there is a range of fine-pointed nibs available that are

pushed into an ordinary dip pen holder. Some of these are pointed and rigid, while others are flexible to allow variations in thickness of line. They tend to have a few more variable lines than the techno graphic pens. You can also vary the kind of ink you use with them to get a blacker or greyer tone.

First, with a pen, try the loose-line technique similar to that of the pencil technique shown on page 126. Use a large nib to begin with and draw with large, flowing gestures. You won't create much tone with this but it does produce a lively looking line, which can be very attractive as long as the subject matter is not too detailed.

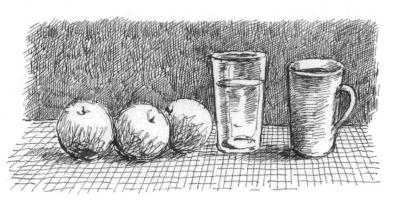

The same approach with a finer nib demands a more tightly controlled scribble effect, which can build up very varied tonal areas, helping to produce more depth and substance in the drawing. Always keep the strokes smaller with a fine pen, because it is the build-up of tiny wavering marks that produces an attractive quality to the drawing.

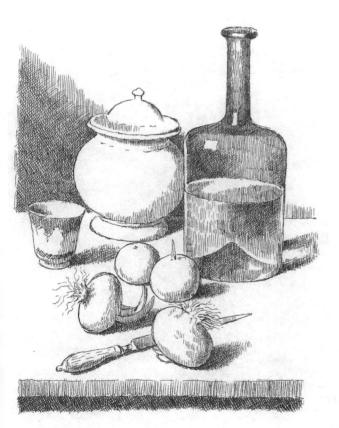

You can use a much more carefully organized system of batching with multiple batching, layered to build up significant areas of darker tone. This demands more precision in the outline shapes and you need to control the way the pen strokes butt onto these finely drawn outlines. Carried out with patience and perseverance, this can produce beautiful velvety textures that seem to create real depth and solidity.

BRUSH AND WASH

Drawing with a brush is a very pleasant experience once you have become accustomed to the flexibility of it. This technique has been used brilliantly by artists over the centuries, including Rembrandt and Picasso. Try varying the intensity of the ink or paint by diluting it with different amounts of water. Hold the brush firmly but flexibly so that it can flow freely along the shape you require. Allow the tip of the

brush to push further onto the paper and then pull it off to make thinner, fainter lines. It produces a very attractive look to a drawing. Try drawing volumes and larger shapes without drawing in pencil first, so that you get a freshlooking shape of watery tone. Don't worry too much about small mistakes; go for the overall effect. It can look very juicy, if sometimes a bit hit and miss.

Note the variable softness of the lines, which are watery and fluid.

Here the full flood of tone, which can't be entirely controlled, gives a very rounded look to the pear. On the grapes, leave areas of highlight to emphasize their juicy fullness. Don't worry about the outline too much, just do your best.

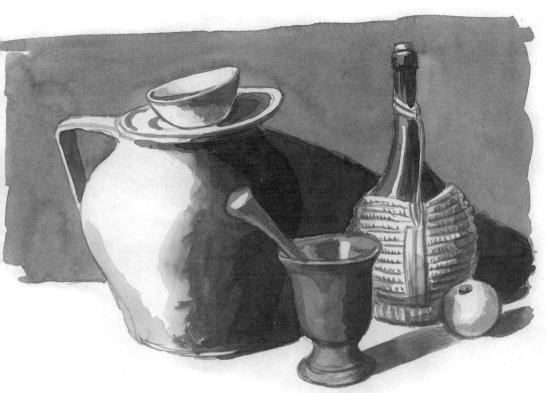

You can make a very fine pencil outline of your objects first and then proceed to lay layer upon layer of watery tones to get a carefully graduated set of shadows from

black to very pale grey. When you employ this technique, try to avoid large areas of one tone unless you are using a good watercolour paper, which makes it easier.

CHALK, CONTE AND PASTEL

The method used for chalk is quite varied and also depends upon the quality of the chalk. Some are quite hard and wear down slowly; others are very soft or crumbly. They demand slightly different handling, so try a variety of them to discover which type you prefer to work with.

The easiest way to use chalk or pastel is on a tinted paper, especially one that has a slightly rough or matt surface; a smooth surface refuses the chalk sometimes, so paper with some texture produces a better quality of line. You will be able to buy some good papers for these media from your local art shop.

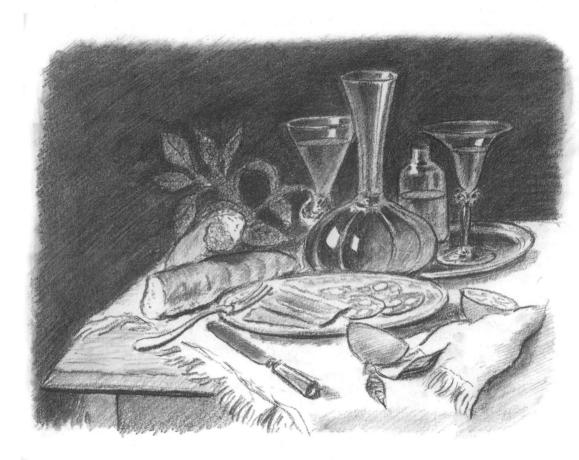

You can take the classical method (similar in some respects to the pencil technique) of building up your picture with layers of hatched chalk lines, all in the same direction, which creates areas of uniform and variable tone to describe the form of the objects on show. Here you have to be very careful not to smudge the lines, because their effectiveness depends on their beauty

of gradation from one tone to the next. Nothing is left to chance in this method, and it has to be carefully planned to get the welltempered effect.

Two shades of tone go a long way to help make this still life work, but don't use white chalk here, where the paper is white. You must allow the white of the paper highlights to show or you will lose half the brilliance.

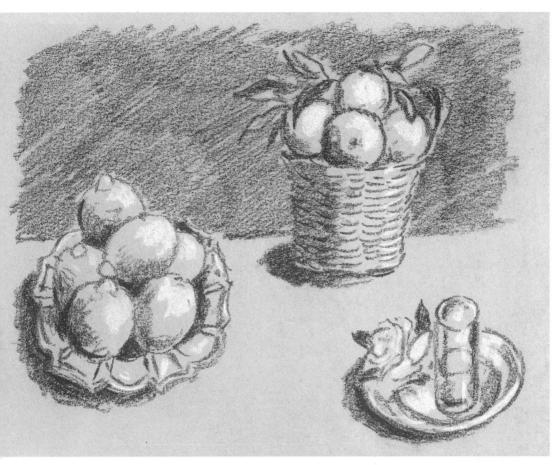

This still life is on tinted paper in a dark and a white chalk. The paper produces the half tones, the dark chalk the deeper shadows and outlines and the white chalk the highlights and bright spots. It is a very effective method, with economical amounts

of drawing to be done; you let the tone of the paper do the work, with you just putting in the more extreme shadows and highlights. You will probably have to fix the final result with a good fixative spray, available from any art shop.

Use the chalk as shown, very lightly stroking the surface of the paper. A carefully sharpened end will give you finer lines. Never apply heavy pressure, which will always give a coarse effect.

MIXED MEDIA

As the name implies, this can mean all the previous methods described, plus the use of paper shapes to glue down onto the picture as well. This method lends itself very much to decorative approaches to art. You can cut out

some shapes and tear out others to vary the interest in the way they are produced. The cutout shapes look elegantly sharp, while the torn shapes give a more rough-hewn appearance to the picture.

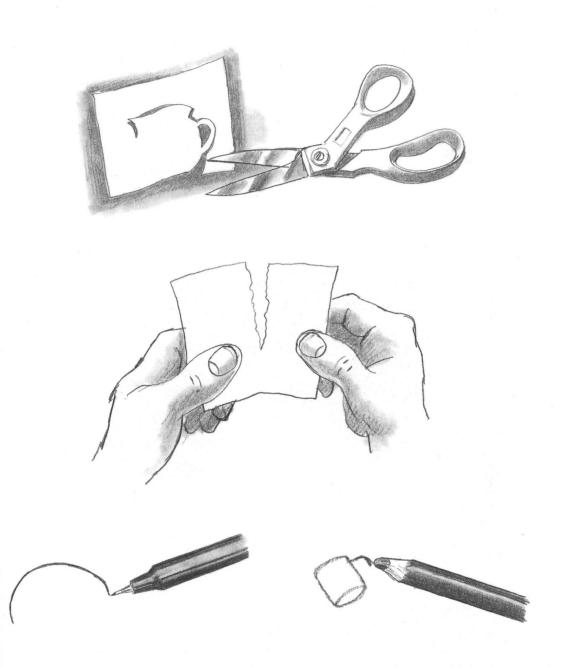

In the example on the facing page, the back of the sideboard is shown in three layers of cut-out mid-tone paper, with several cut-out shapes in paler paper stuck on top of the background shapes. The smaller items on the dresser are drawn simply and decoratively in lines of fibre pen ink or soft chalk shapes.

EXAMPLES FROM ART

Now we will look at examples by well-known artists of the methods just described to give you some idea of the variety of approaches possible. I have interpreted some of them in a medium other than that which was used in the

original work. This shows how any picture can be freely redrawn in a different medium which can give it a new, interesting effect, so don't hesitate to copy masterpieces in different techniques for practice.

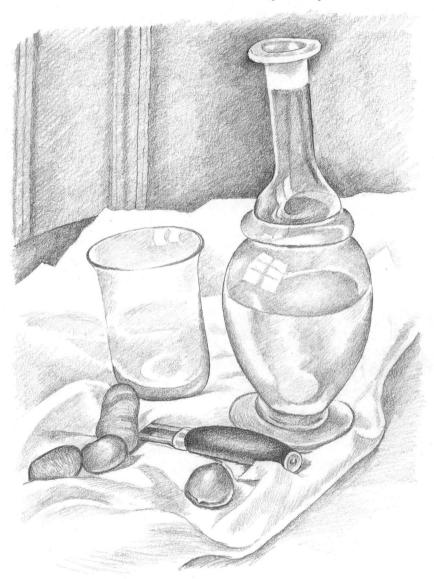

Here we look at a still life by Diego Rivera, the revolutionary Mexican artist who painted many large murals in the 1930s and 1940s. This rather refined pencil drawing looks anything but revolutionary, with its carefully gradated tones, which give a strong effect of texture and dimension. The only thing that tells us it is a 20th-century drawing is the rather naïve wobble to the decanter and the simplicity of the folds of the cloth. Apart from that it has a timeless elegance. I did this drawing with a 6B pencil on cartridge paper.

This piece of drapery is after a Leonardo da Jinci study. Rendered in a painstaking ink echnique of hatched lines, it is a very classically inspired piece of work. A fine pen

nib lends itself very well to this sort of drawing, although there were at least two grades of nib size used here in order to obtain this effect.

Matisse's still life in front of a window with an Egyptian curtain is rendered in brush and wash technique which is kept very simple to suit the style favoured by Matisse. The solid

tones and the pattering of the shapes is a favourite device with this artist, but requires great discrimination in exactly how the complex original should be simplified.

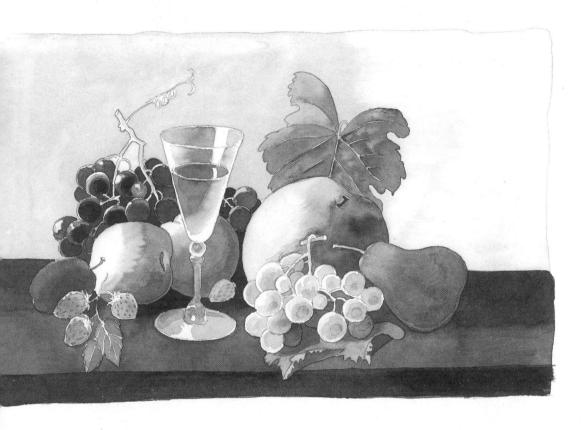

This much more traditional Renaissance-type drawing, after a painting by Severin Roesen executed in 1870, is a graded wash of tone inside carefully drawn pencil outlines, and requires a great deal of control of your materials and tools. Try it out, but don't be

discouraged if it doesn't always work. It takes a bit of time to get the precision needed in handling the brushes and pigment. To make it easier, use a good, thick watercolour paper. The tonal wash will diffuse better and be easier to control.

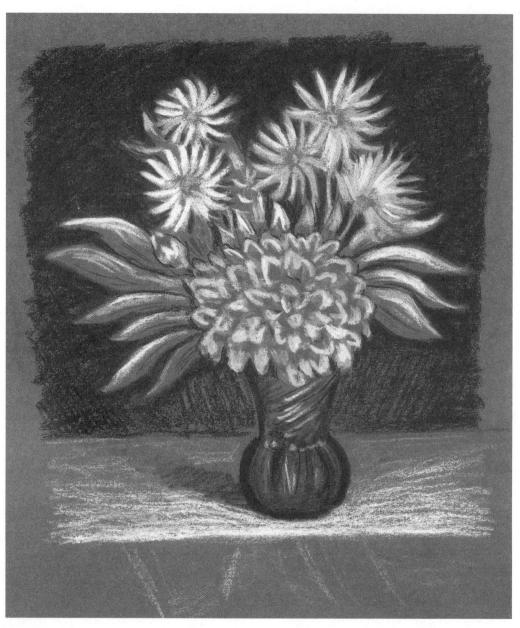

A chalk drawing like this one after Henri Rousseau (Vase of Flowers, 1900) can be very powerful and decorative at the same time. The simplicity of the repetition of shapes and

tonal patterns make this an almost folk art kind of picture, and the intensity of the chalk on the tinted paper provides a powerful impact, heightened by its simplicity.

Henri Fantin-Latour's painting Still Life of Fruit, Flowers and Wine translates very well to the medium of chalk because its very subtlety of texture makes it ideal for the nysterious quality of Fantin-Latour's

pictures. This has been drawn very lightly and delicately on a heavy watercolour paper, which helps to break up the surface of the chalk strokes. Do not forget to fix chalk when you have finished your work.

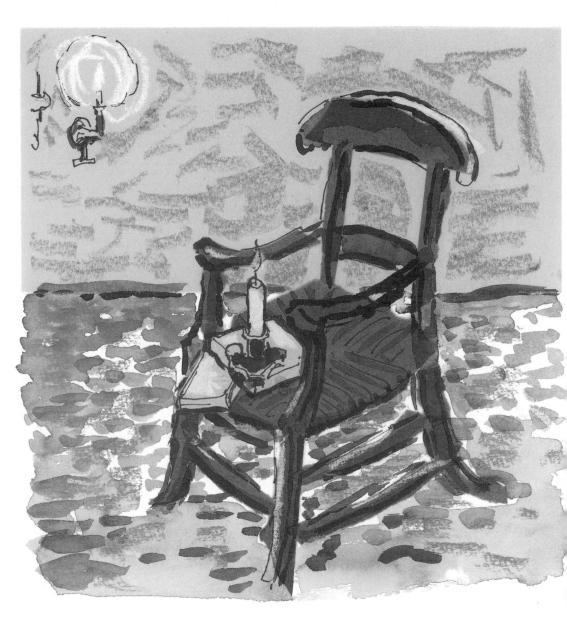

A mixed media picture based on Van Gogh's still life of Gauguin's chair with books and a candle in a gaslit room with a patterned carpet. Some mid-tone paper was torn and cut and stuck down on the watercolour paper and on light-toned paper. Then inky

washes were drawn over it with a brush to reinforce the shapes of the chair, and a fibre pen was used to draw in some of the more detailed parts. Chalk was then used over this to create more texture and a slightly gritty line effect where there are highlights.

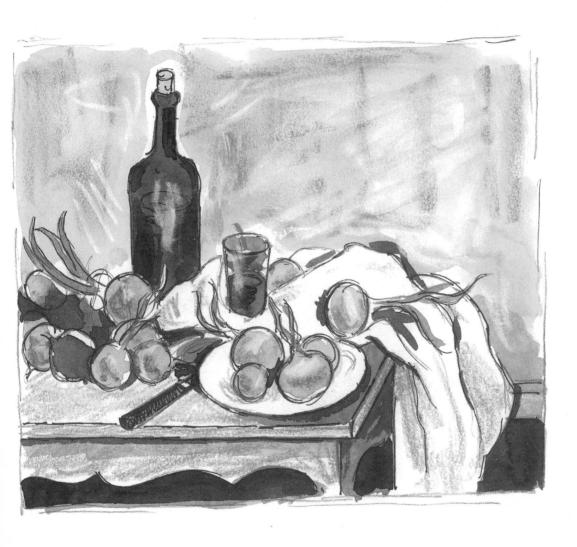

A similar still life based on a Cézanne Dicture was done rather more finely in pen 'ine, chalk texture and washes brushed across some areas. In some places the chalk is on top of the wash and in others the wash is over the chalk.

Playing with Still Life

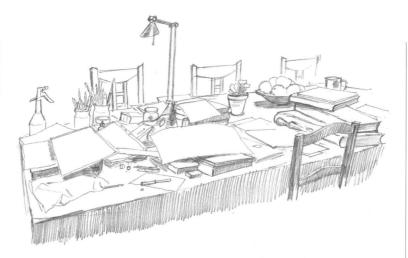

HIS SECTION DEALS WITH THE BUSINESS OF trying out compositions and arrangements of still-life objects without necessarily drawing them at once. The idea is to turn the still life into a game of possibilities and hope that you will come up with something that intrigues you visually and compositionally. It is easy enough to throw together a group of objects with little concern as to their aesthetic possibilities or the emotional response they evoke. However, once you become interested in producing really good compositions, you will have to experiment with different objects and arrangements.

The way to get the hang of composition is to do things such as clustering large amounts of similar objects together so that they begin to define the space that they occupy with some force. Repetition of shapes is a very traditional way to produce a powerful combination of form in space. Another way is to line them up like a military parade, but looking carefully at how they

are lit. Morandi was a great believer in this method, although his objects were not always of a similar shape.

An opposite approach is to create a large space such as a table-top with just one object centred in the picture to help define the space. This usually means that the object you choose should be picked for some significant thing about it, either in its shape or its materials.

Pinning up a large number of flat items such as letters, photographs and pamphlets on an obviously flat surface can create great opportunities for trompe-l'oeil drawing, where the shallow relief of the object can be emphasized by careful modelling which can begin to cheat the eye into believing that these things exist as real objects. This does take skill to do, though.

Taking a working environment and just portraying the normal arrangement of tools, gadgets and other paraphernalia of the job can create quite a strong, austere effect of work in progress.

Choosing larger objects such as pieces of furniture and putting several of them together in a small space can be very interesting for defining the significant negative space between them very clearly. This does make us look at quite ordinary objects anew.

Everyday objects of a small size – things that can be easily held in the hand – drawn with great definition and to a scale much larger than their normal size, provide a great way to see familiar objects in a new light. Treated in this manner, they can become quite compelling.

A theme where you try to show a variety of different textures in one picture, demonstrating your skills, is quite amusing and creates an intriguing puzzle for the onlooker to decipher. Similarly, taking the five senses and drawing up images which suggest each one has a sort of elemental power and logic about it and helps to create unusual compositions.

MORE OR LESS?

Here we take similar objects and look at them in different ways. They can be lined up à la Morandi, making a neat, closely grouped picture, or multiplied *en masse*, creating a crowd of objects without limit. Alternatively, we can get rid of everything except one perfect specimen and set it in a big empty space so that it becomes the focal point.

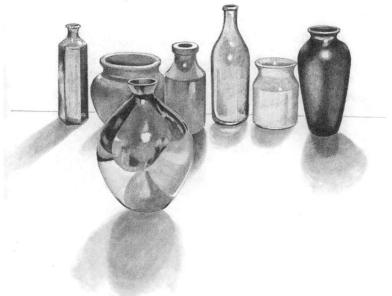

In this line-up of pots of different types and materials, all are centred on a circular base. Lined up with the light behind them, they present an attractive group with a formal balance. The placing of the brilliantly reflective pot in the front is rather like putting the king in front of his troops.

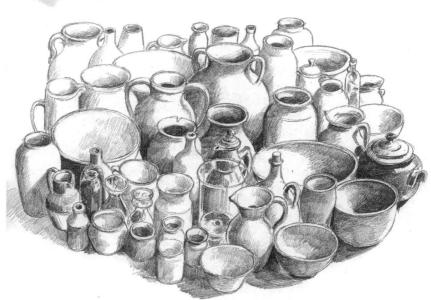

This composition was arrived at by gathering together most of the vases, jugs, large bowls and other pots from our kitchen, sitting room, hall and garden and pushing them together, large at the back, small at the front, all across

the floor. The repetition of these mostly openended shapes seen in perspective creates an intriguing picture. One 20th-century English artist produced a composition of 100 jugs – something of a challenge to tackle.

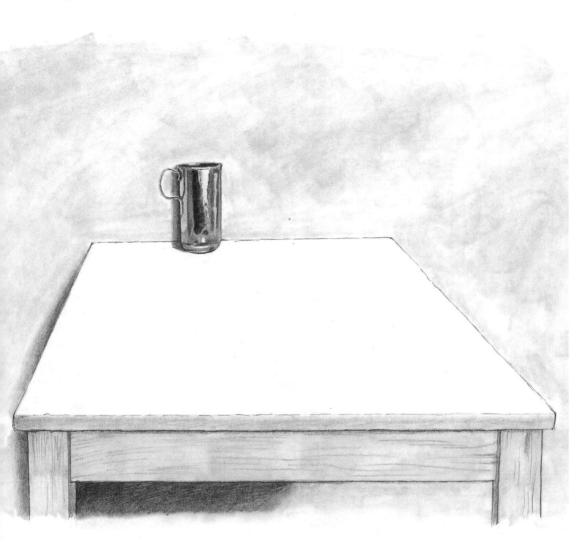

Taking a single object like this golden jug and placing it on a bare, simple table with a blank wall behind it pulls the eye into the

picture to concentrate on the lone object. For maximum effect, choose a really strong, unusual object.

SHALLOW OR DEEP?

The pinboard with various paper articles pinned and wedged onto it gives a very good display if you want to try out your hand at a little trompe l'oeil. Making sure

the objects don't have much real depth helps here, because whatever amount of dimension you manage to get into it pays off quite strongly.

large table-top laden with miscellaneous objects can be intriguing, especially if they are objects that are not familiar in that context.

A lot of old pictures of still life were done like this, but usually with a precise theme. This drawing is just of what happened to be there.

ORDERLY DISORDER

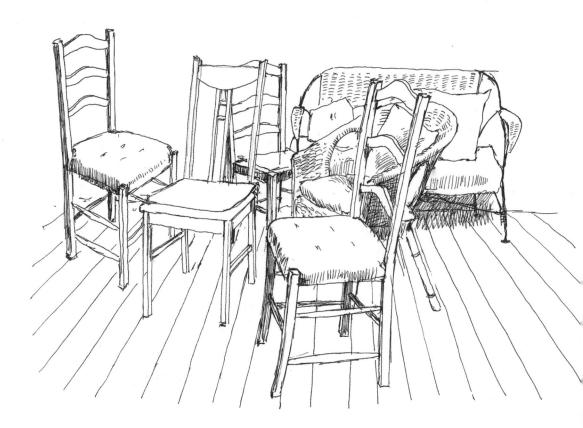

These chairs of various shapes and materials scattered across the wooden floor in no apparent order make interesting visual

spaces in between their forms. Large objects always force you to look again at your efforts to compose well.

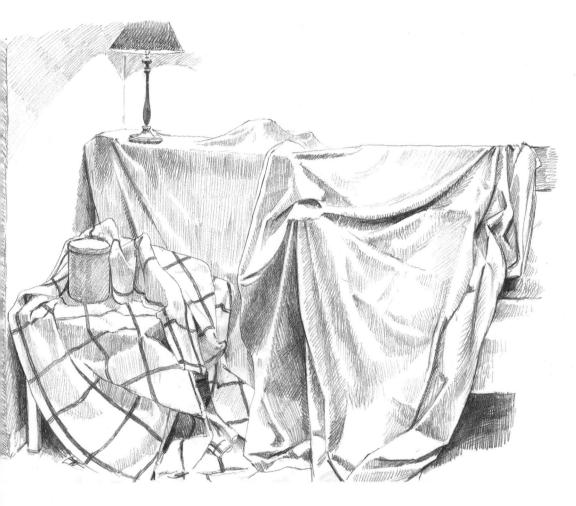

The large cloths, both plain and patterned, draped over some pieces of furniture and anchored by a lamp and biscuit tin, create

an interesting artificial landscape of folds and wrinkles. These were very pleasing to draw, albeit challenging.

USING WHAT'S AROUND

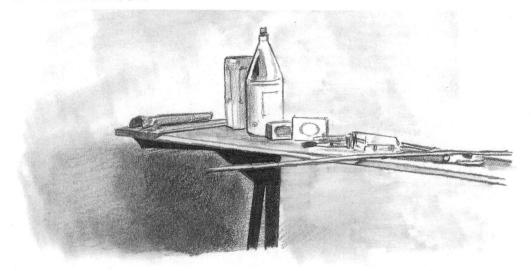

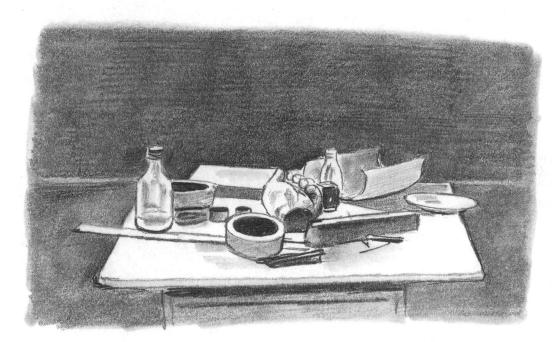

The various pictures that the British artist Rodrigo Moynihan painted of his working environment are cleverly composed and

bandled with powerful simplicity. Have a go at creating some compositions from your own working space.

SMALL TO LARGE

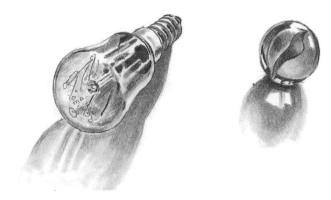

Small hand-held objects such as keys, bulbs, gaming pieces, matchboxes and assorted implements are always good for still-life subjects, but look better the larger you draw them. This makes you learn quite a bit about scale and is great fun to do. Try a drawing pin or paper clip drawn about 30 cm (12 in) in size.

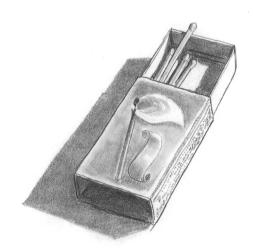

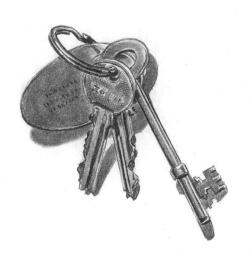

TACTILE QUALITIES: THE SENSES

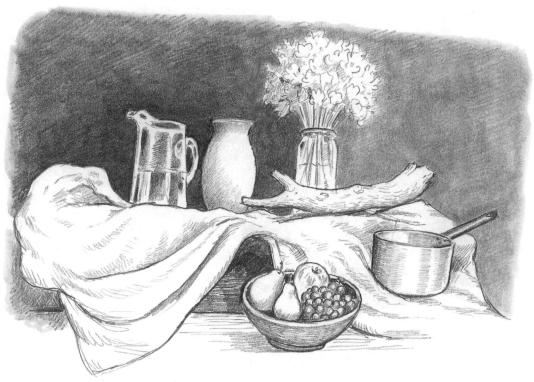

Taking a group of objects each of which is made from a different material is a timebonoured way for a still-life artist to show his skill in depicting the texture of things.

Here we have glass, pottery, flowers, wood, metal, fruit and cloth, all of which need to be drawn differently in order to bring out their texture.

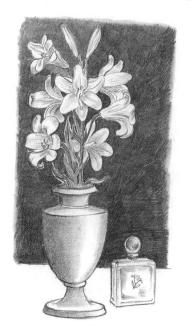

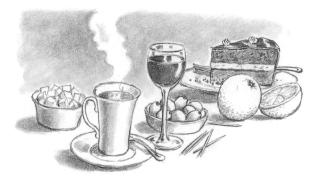

In this composition of a warm drink, a sugar bowl, a glass of wine, some olives, some oranges and a nice rich-looking cake, all the items refer to taste.

A vase of lilies, which have a strong scent, and a bottle of perfume put across the idea of smell.

Here there is a group of objects such as a lamp, a camera, a pair of binoculars, a book, a magnifying glass and spectacles, all of which are referring to sight.

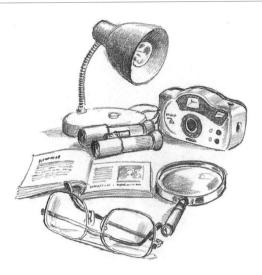

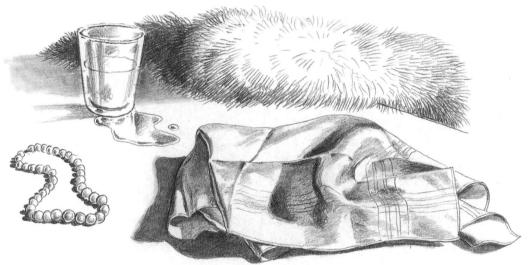

Taking a theme of the five senses allows us to try to show something that everyone experiences through the medium of drawing.

The drawing above refers to touch, showing silk, pearls, water and fur, all of which have great tactile values.

Finally, a group of musical instruments puts across the idea of sound and hearing – a classical subject.

Unusual Arrangements

N THIS SECTION WE CONSIDER SOME UNUSUAL STILLlife ideas which innovative artists over the centuries have experimented with, and developed. Of course, what is at first very unusual often becomes acceptable, even fashionable, and finally very familiar to most people.

The ancient civilizations often seem to have produced still-life arrangements in their paintings, which were mostly wall decorations. The Athenians knew of pictures by Phidias which were reputed to look so real that people tried to pick up the objects. On the walls of Pompeii and Herculaneum there are some beautiful pieces which survived the horrendous events that overtook those cities. There are many historians who believe that the best painters in Southern Italy were also Greeks. The Romans certainly learnt their skills from them.

In this section you will find an example from Italy of the genre I call "menu" pictures. In the main dining room at the 15th-century Medici Villa at Poggio a Caiano in Tuscany, Italy, the walls are covered with large paintings of the produce of the estate, such as various types of grapes, pears, lemons and so forth. This sort of still life was commissioned for the particular purpose of satisfying the desire of aristocratic landowners to be surrounded by representations of the bounty of their estates while they enjoyed it at their tables.

Here the intention was to illustrate food at its most tempting, something that was echoed centuries later in the commercial world of advertising. In its early days, it gave rise to a whole area of representation of products that was called "commercial still life" in the art schools at the time. These slick, well-drawn pictures of products decorated packaging, posters and press advertisements, a genre that was replaced by the use of photography instead.

At the opposite end of the scale of realism were the still lifes produced by the Surrealists. They painted pictures of objects in distinctly odd situations, juxtapositions and forms. Our example is by Salvador Dali, the most famous representative of this school of art, and shows one of his most well-known works.

After the Second World War, the artists' movement called the Kitchen Sink School concentrated on looking at the ordinary, messy nitty-gritty of life's activity which until that time had largely been ignored. This genre gives scope for every artist, for even the lavatory in a domestic bathroom can become a legitimate subject for a still life.

You don't always need to find an unusual subject, or handle a familiar one in an unusual way; sometimes just the framing of a picture can produce an unexpected effect. Even though still lifes have a long history, there are still many ways to break new ground.

PICTURES WITH A PURPOSE

This still life can be seen at the Medici Villa at Poggio a Caiano in Tuscany and is one of many that were painted for the powerful Medici family to depict the bounty from their own estates. Here there are about twenty paintings on the dining-room walls that catalogue every type of fruit, vegetable and animal that was produced from the estate – a sort of menu of the raw materials of what your dinner would be. My drawing is taken from about 30 varieties

of lemons shown on a latticework of leaves, each group of two or three being a different variety. It almost looks like late Victorian wallpaper, except that every piece of fruit is carefully observed from nature. This is a really enormous still life piece.

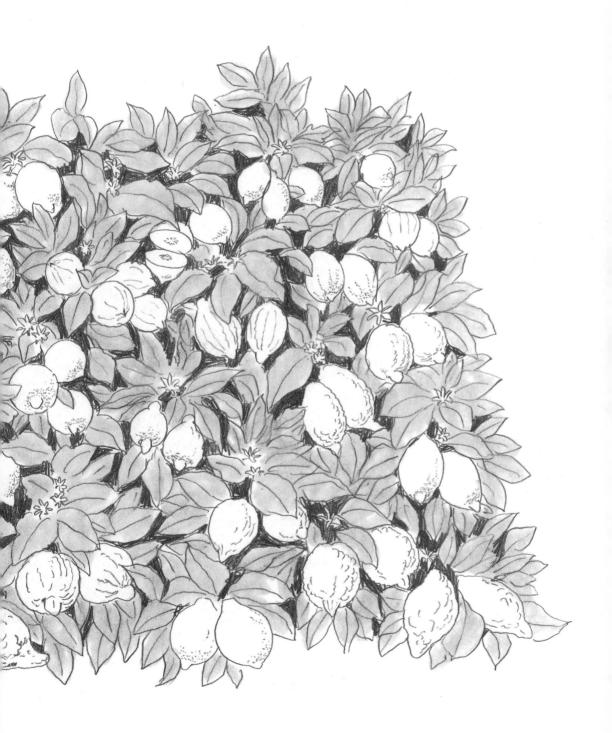

This is a commercial still life taken from a 1930s advertising campaign designed to boost the consumption of spaghetti. During this part of the 20th century there was much still life drawing of this kind being produced, some of it demonstrating quite a high level of artistic skill.

These eggs and pots are from one of the earliest pieces of still life extant – a fresco painting from the walls of Pompeii, which

was preserved to the present day by the volcanic eruption of Mount Vesuvius, which buried it in lava and ash.

Here is something distinctly odd: a Surrealist still life that is also partly a landscape.
Although the objects are from everyday life they are given a new twist by the fact that they seem to be soft and melting instead of

bard and rigid. Salvador Dali's melting watches are famous and it is quite a feat to be able to paint such things in a way that makes them still recognizable while changing their shape so dramatically.

RECORDING THE EVERYDAY

The 1950s movement in British painting called the Kitchen Sink School (an equivalent of the American Ash Can School), believed that too much of the painting of the time harked back to

the subject matter of the Impressionists or post-Impressionists and decided that everyday images of life in its gritty, mundane reality would be their concern.

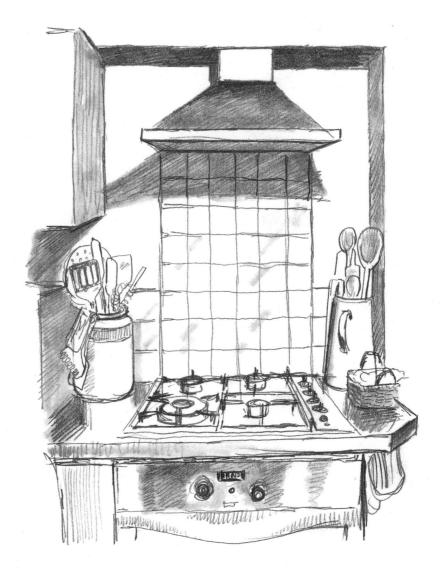

I thought that the everyday could be an unusual and interesting area for still life, so I looked around my own immediate surroundings and started drawing the top of the cooker with a pot of metal cooking utensils on one side and a jug of wooden

spoons and assorted implements on the other. The unromantic view of the top of the cooker with its knobs and gas rings and the extractor fan overhead completes this unvarnished still life of the centre of kitchen activity.

This is almost the only angle from which to draw a lavatory, although you could sit down in front of it and have the seat at eye-level. I was influenced in this by John Bratby, who produced a similar view of his lavatory, although he also included a pipe and cistern high on the wall with a pull chain.

Then I went to the bathroom and took as subjects the rack where the soap and shampoo bottles are kept with a couple of flannels hanging below.

The point of this exercise is not to be too sensitive about how you portray this subject; just draw it as it appears to you from the most obvious viewpoint. My bathroom is so small that I could draw this easily from only one position and so I simply did that.

FINDING AN INDIVIDUAL STYLE

Next, we look at unusual still lifes which derive their originality in part from the method of drawing that the artist has used. The rather mechanical outlines of the example below and the obsessive groupings of that on the facing page give a different look to these still-life objects that has become almost iconic. What you can see here is that sometimes just the way you draw can produce the individual quality of the picture that gives it particular interest.

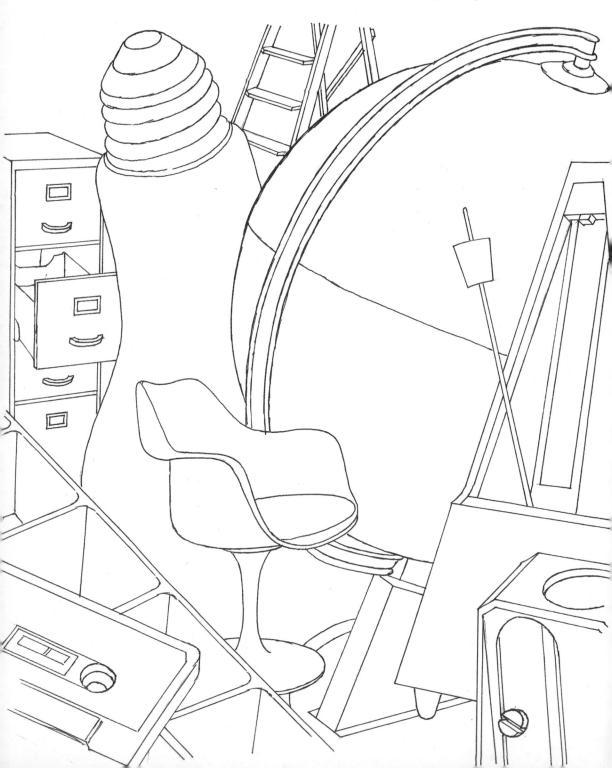

In the linear drawing shown left, after Inhale, Exhale (2002) by Michael Craig-Martin, the ordinary mechanical gadgets of modern living are thrown together in a way that confuses the onlooker by placing large objects such as filing cabinets and step ladders against scaled-up versions of a video cassette, pencil sharpener, light bulb and metronome. The pedestal chair in the middle acts as a focal point, and the whole picture is pulled together by the almost mailorder catalogue style of the impersonal drawn line. Michael Craig-Martin is one of the few artists who use this sort of technical detachment from their subject.

The group of pictures on the right is after the Still
Life Series (1952) by the artist Morandi, who
spent the latter part of his working life producing
picture after picture of almost the same objects,
grouped in a very similar way. This obsessiveintensive method of artistic production does yield
extraordinary results after a while and this
artist's work is much sought after nowadays. The
careful repetition of theme, which forces the artist
to look closer and harder each time to discover
the inner qualities of the subject matter and his
responses to it, seems to create an almost
mystical intensity of depth of emotion, but
recorded with increasing detachment.

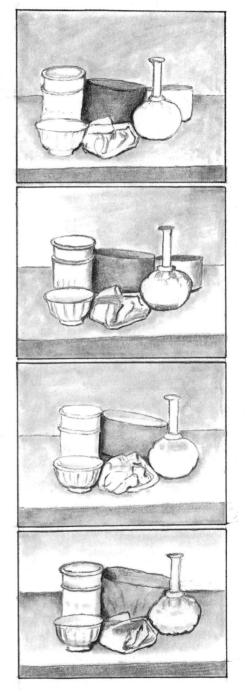

UNUSUAL SUBJECTS

Most artists are called upon at some time in their career to produce pictures of unusual things or circumstances, and still-life subjects are no different from other genres. Many of these examples are time honoured, if not very often attempted, and indeed some of the earliest pictures from the Roman world are of still-life subjects. Sometimes the subject is symbolic, sometimes distinctive, and sometimes just odd. Many are of subjects you might not ever think of for a still life unless you were to receive a commission.

This still-life arrangement is really only unusual due to special weather conditions. All the outdoor living furniture for relaxation on a warm day in an equable climate looks distinctly unusual after a snowfall, so a picture which might have looked

unremarkable in its more usual conditions becomes rather interesting when the weather lays a white blanket over the objects. Be alert for such events and seize the opportunity while you can – this snow had gone by the following day.

This picture is after one of the oldest still lifes in existence, a Roman mosaic. I am not suggesting you tackle mosaics, but as you will see on page 174, this subject matter can still be used today with good effect. Here the Roman artist has carefully depicted odd bits of residue from a feast that might have been

dropped onto the floor during the meal. The very accurate depiction of the shells of sea urchins and shellfish, the pips and stones of olives and fruit, the stalks of grapes and the remains of gnawed bones of fowl make a very interesting allover pattern.

The humble, worn footwear that Van Gogh drew in the 19th century is an earlier version of the approach of the Kitchen Sink and Ash Can schools of painting. When Gauguin showed the work to some of his friends they were surprised by its apparently banality. Of course what Van Gogh had depicted in his picture is the honesty of hard toil and a sort of sanctified poverty that seems to give an extra psychological depth to his drawing.

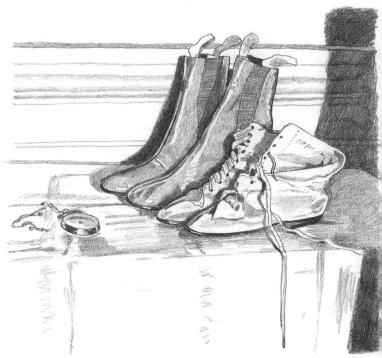

Williams Nicholson's subject matter (Miss Simpson's Boots, 1919) is right at the other end of the social scale from Van Gogh's workman's boots and seems to say a lot about the genteel, even pampered lifestyle

of a favourite daughter of a rich family.

Today we might feel that there is even a hint of shoe fetishism about it. Even the most ordinary everyday equipment tells us a story if we want to look for it.

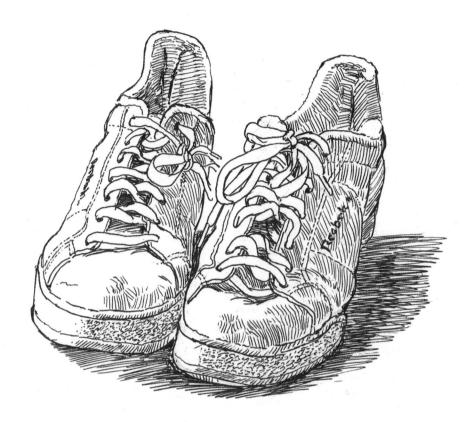

Oddly enough, these extremely egalitarian trainers look similar in nature to Van Gogh's workman's boots, but they were designed for leisure pursuits which only an affluent part of society can afford, however worn they look at this stage. Footwear sometimes provides an ambiguous message about its owners and the society in which they live.

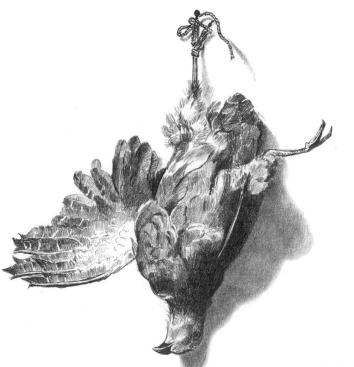

Many pictures in the 17th and 18th centuries, when every gentleman partook in hunting in some form, showed dead game birds. Most of our goods come to us so well packaged that it is easy to forget that much of what we eat was at some time a living creature. This is a real piece of still life, or nature morte.

Not many of us have been in a slaughterhouse but Rembrandt was a frequent visitor, recording the activities of daily life in some detail. Here we see the trussed body of a slaughtered pig.

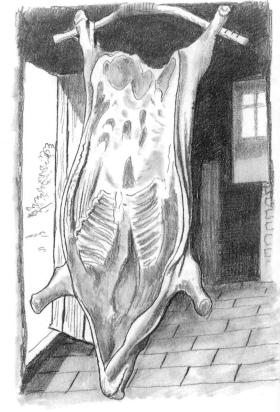

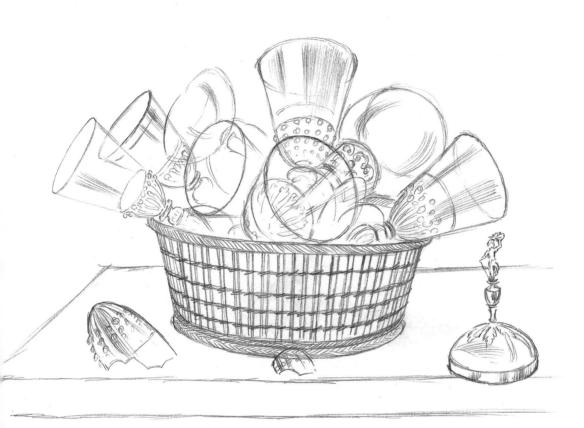

This is an odd choice of subject matter: a number of rather elegant glasses placed together in a basket. It is an unusual way of holding glasses, and the picture suggests that indeed it has been responsible for breakages occurring. An interesting variation on the classic bowl of fruit as a subject, it raises questions in the viewer's mind.

RARITIES

This picture may not seem unusual in itself, but if you look through the history of still life there is very little that deals with a table prepared for a meal. One reason for this might be that table arrangements can be so complex and full of different objects that a depiction of them can end up looking a muddle. As you can see, in this example of what is really only three places set at the end of a table, the mixture of tall items such as bottles, candlesticks and glasses

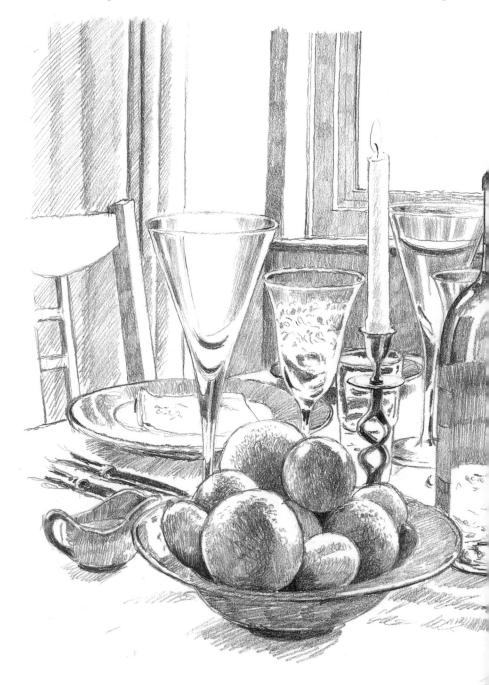

and flat objects such as plates and cutlery does make for a forest of shapes. However, the intermediate height of the bowl of fruit and sauceboats helps to bridge the gap between them. If you have ever looked at an old edition of Mrs Beeton's cookery book you may have found in it drawings of place and table settings that appear remarkably like a doll's house tea party, with everything very small on expanses of white tablecloth.

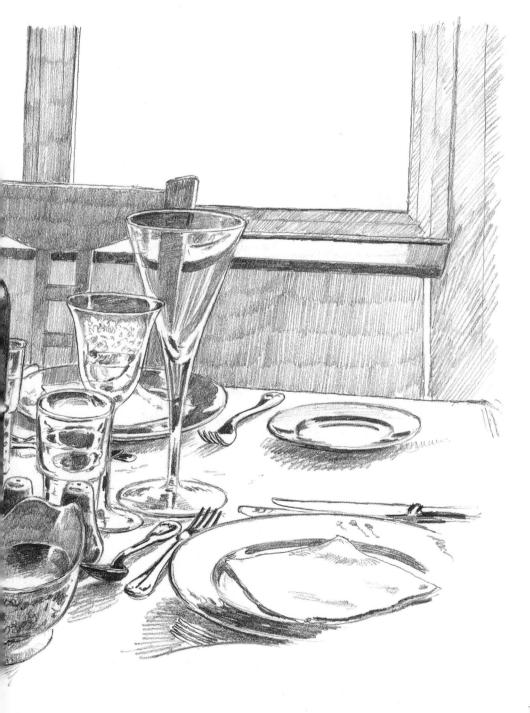

This picture of kitchen detritus was inspired by the Roman mosaic at Pompeii on page 167 showing scraps of food dropped on the floor. My example was easy enough to do: I just gathered some bits and pieces such as dead matches, crumpled paper, crusts of bread, the odd bit of orange, a spoon and an apple core; the results of a day's household activity. Then I scattered them onto the kitchen floor to make them look as natural as possible.

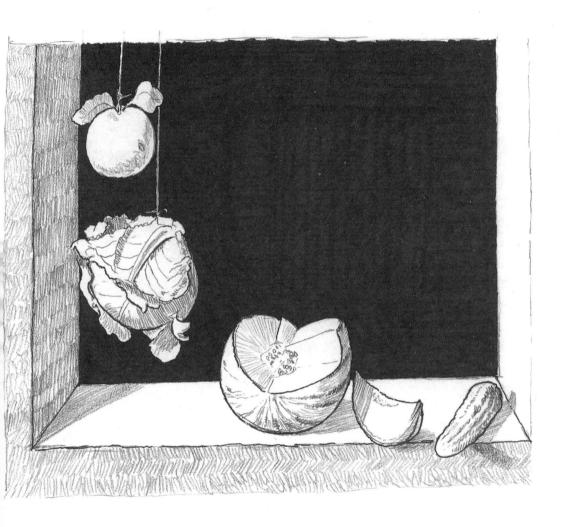

This extraordinary still-life arrangement by 'be Spanish artist Juan Sanchez Cotan (1561–1627) is a carefully designed curve of vegetables and fruit set in a window-like pace. The position of the quince and cabbage's such that, with the melon and cucumber, be curve is geometric and according to most art historians this has symbolic significance.

No one is quite sure what the symbolism is, but it might have some reference to biological science, which was beginning to become of great interest to 17th-century scientists and artists. The black background helps to lend an even more formal effect to the composition. Cotan painted several versions of this type of picture.

This is after the 16th-century Italian artist Archimboldo, who specialized in making pictures resembling portraits out of still-life objects. This piled-up stack of open and shut books draped by a background curtain produces an effect of a bearded man sitting for his portrait. It is definitely still life, but also becomes a portrait by virtue of a sort of optical illusion – a clever and very difficult approach to pull off.

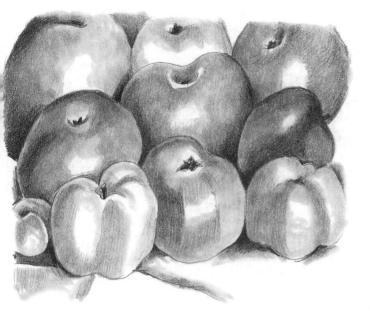

The 20th-century American artist Georgia O'Keeffe often produced very large pictures of flowers, fruit and other objects. In this picture we have a number of apples laid out without any careful pattern – just rows of apples going off both sides of the picture and out of the top. The close-up effect of such a simple arrangement creates a very different effect from more classical still-life pictures.

Georgia O'Keeffe produced pictures of large cow skulls, one of which is shown here with two calico roses attached and a couple of curtains behind. It is difficult to know what the idea was behind these, but they are very dramatic in effect.

Cornelius Gijsbrecht's picture (c. 1670) shown above is one of the oddest and most amusing still-life subjects I have ever come across. It is apparently the reverse of a framed canvas, but is in reality a careful drawing in a trompe l'oeil manner actually painted on the

surface of a canvas. Presumably the other side of it looks the same but is the real back of the picture. It is a nice joke, which probably works better as a painting than a drawing, but I could not resist including it as a remarkable piece of still-life composition.

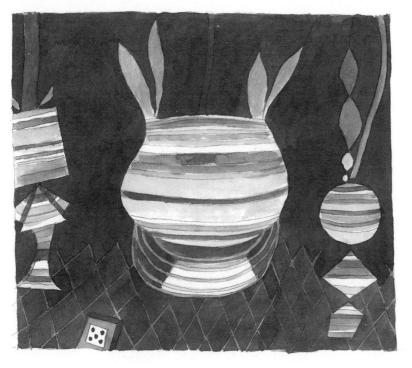

20th-century artists were interested in the still-life genre, but because of their desire to use a new language in art they produced some unusual variations upon traditional themes. This picture after Paul Klee of potted plants and a die on a paved floor gives a mysterious effect which is very different from the more photographic view of still-life objects.

Juan Gris, a French Cubist artist, produced his own Cubist version of still-life pictures, based on the classic 20th-century still-life arrangement of a plant or newspaper and other objects, but with all of them carefully deconstructed to show varying planes of patterned surfaces overlapping each other. Are they flat or three-dimensional? This ambiguity helps us to think about the business of making flat drawings look three-dimensional by reversing the process.

The French surrealist artist René Magritte produced many odd pictures and this one has a double joke to it. It is a reference to Manet's picture The Family on the Balcony, but because they are now in their coffins it is a large still life or nature morte of curiously constructed coffins. Thus it is both a still life and a family portrait.

Bringing It All Together

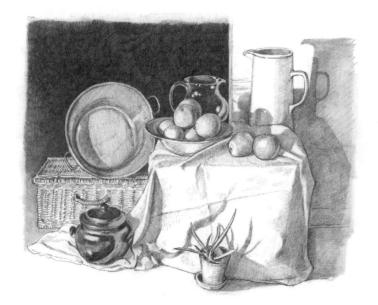

O NOW WE COME TO THE LAST STAGE OF THIS BOOK, which is to practise doing a complete still life from the very first thoughts to the finished picture.

Where do you start to look for a subject? Well, you may find a marvellous ready-made still life arranged in a room by someone else who had no thought of it becoming a piece of art. I often come across a tempting still life in my own house where objects have been left in a different position to that in which they usually stand. However, for our exercise here we will assume that nobody's been kind enough to arrange anything for us, so we will have to start from scratch.

The first problem is always to choose the objects, and this can be done in different ways. You might want to create a theme, in which case you will have to make sure everything you choose for the still life fits in with the theme to advantage. Another approach is to choose objects that fit together aesthetically, perhaps with harmony of shapes or interesting contrasts. In this type of arrangement, each object would only be included for the way its shape related to the dynamics of the other objects. Then again you might want to use only objects which to you represent some form of beauty, either of shape or texture, and which all together would produce a satisfying effect.

So there are plenty of approaches to try, but in this particular exercise we shall use a much simpler method. To make things easier for your first big scheme, the idea is to choose only objects that are easily to hand around your house. This means that you may put quite different things together but they will all be accessible, and you will not have to go out to find anything special for your picture. Needless to say, we all make certain choices when acquiring objects for our houses so they will probably share qualities in common.

When you have got some idea about what is available you can begin to consider the final picture. Do you want something big and sprawling, or something tightly composed with related objects? Do you require a large space around your arrangement, or will you set it to one side of the picture? What about the depth of the picture? Do you like to see everything grouped closely, or would more contrast between further and nearer objects be to your taste?

Finally you will have to consider how the picture is lit. Is a side light the best, and should it be natural or artificial? If you are drawing in the winter months and the light is bad, artificial light is the only option. On a bright day in the height of summer, daylight is a better choice unless you want some specially focused lighting. With all those decisions made, you will be ready to start.

FIND YOUR OBJECTS

First, make a selection of some objects that both appeal to your eye and are sufficiently varied to give you the possibility of creating interesting arrangements. Look around for things that you will not need to use in your day-to-day life during the period that you are drawing them. It is awkward if you are drawing your still life and suddenly the saucepan right in the middle of it has to be used to cook lunch, for example.

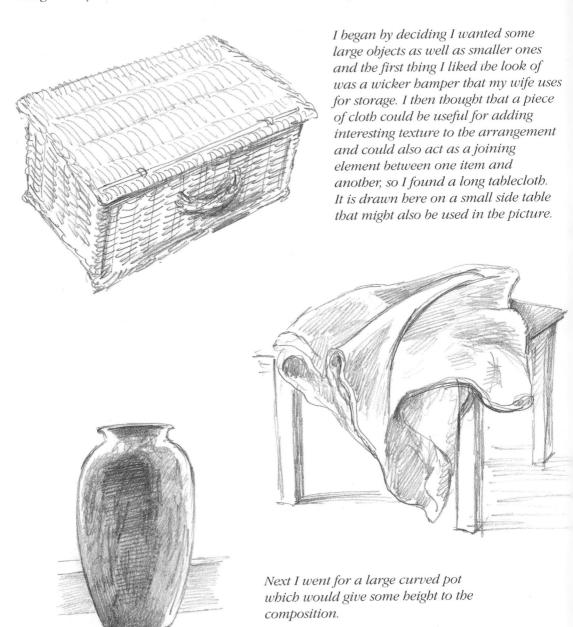

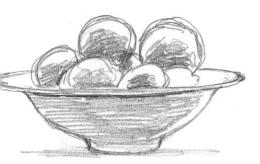

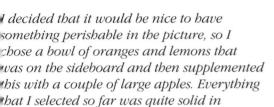

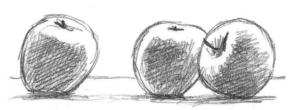

substance, so I found a rounded glass jug which would add a certain brilliance and transparency to any arrangement. Then I noticed a large copper pan that my wife uses for making jam and added that to my store of objects.

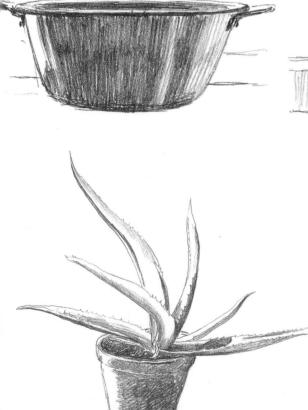

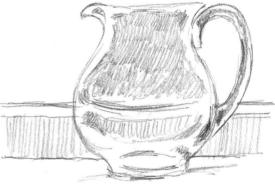

The next thing I thought to use was a potted plant to bring a bit of life into the picture. This succulent plant seemed to be a good bet, as it wouldn't die on me.

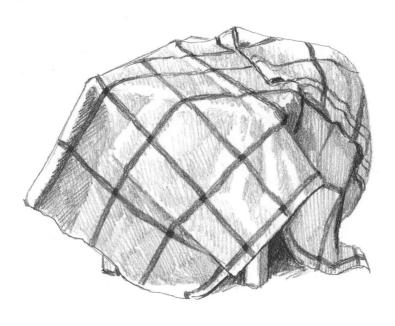

Looking at the cloth I had selected, I thought I should have an alternative, so I found a large check tablecloth that would give me another effective prop. A half-finished bottle of red wine and a large, oddly shaped empty glass bottle were the next objects that I considered for the composition.

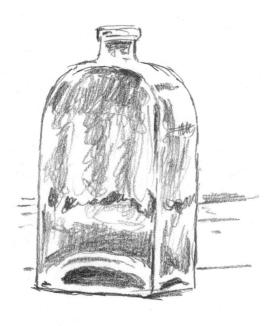

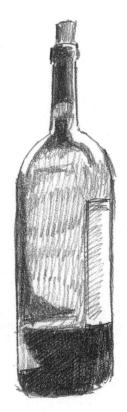

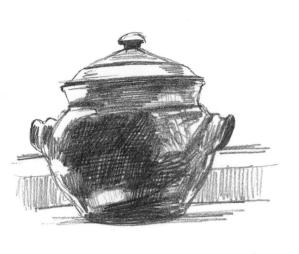

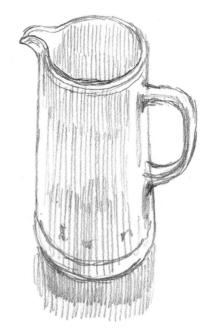

I then spotted a heavy casserole with a lid, a tall white jug, a large pottery jug and a glass bowl, all of which looked interesting in their shapes and texture. Now I had collected

together a good selection of objects, which I would later have to go through in order to whittle them down to the final ones for the finished composition.

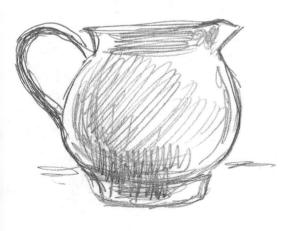

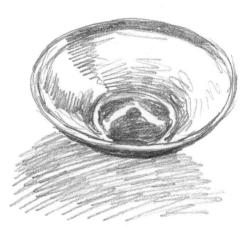

FIND YOUR SETTING

The next step was to consider an area in which all these objects could be gathered together to make their effect.

My gaze then fell on a side table by a wall. It had plenty of space around it, and the wall could act as a backdrop.

The last place I considered was a basketwork chair underneath the windows, again with plenty of space around it.

After all this, I began to think that the best option so far was the area by the side table, which not only was well lit and spacious, but also had a bit of wall and also a large darker space which might be useful to give depth.

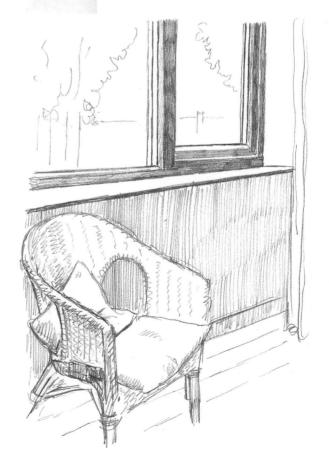

HOW TO LIGHT YOUR OBJECTS

Whatever your still-life arrangement is, there will always be the problem of how the objects within it are lit. There are many ways of doing

this using artificial and natural light. Here we look at just two solutions, but many more variations are possible.

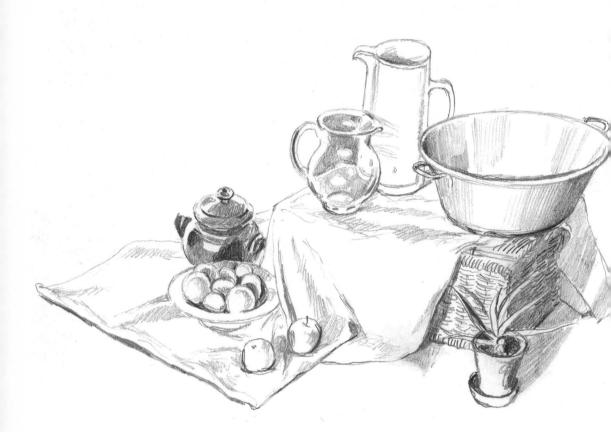

Now was the time to consider lighting. How would I like my arrangement to look? I placed a few of the objects around and on the table in such a position that the light from

the windows lit up the arrangement very brightly. The rather flat front lighting gives a very clear view of the various shapes of the objects.

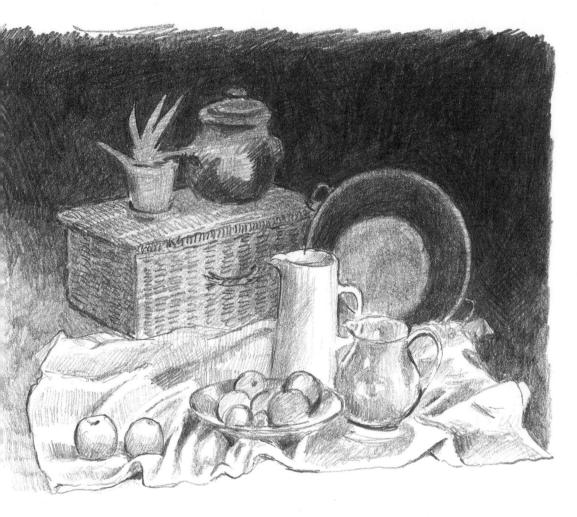

Then I rearranged them against a darker background and put several of the objects well back into the gloom of the space. Only

the objects to the front of the composition were well lit, which gave a lot more drama to the picture.

SELECTION TIME

Now I decided I must select just some of the objects and reject others. There were too many

for what I wanted to do, so I carefully looked at them all again and made this selection.

I chose the heavy pot for its solidity, the tall jug because of its height and simplicity and the bowl of fruit as a classic still-life object. To these I added the glass jug for its light reflection and transparent qualities, and the two apples to act as a sort of loose end to any arrangement.

The big copper pan was retained for a strong, simple shape that would work in either foreground or background.

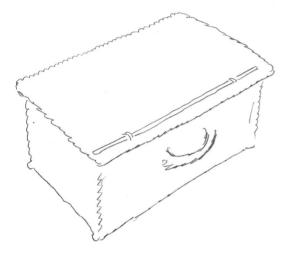

I added the wickerwork hamper for stability and for putting things on, and the side table with the plain white cloth. The cloth could be used in many ways but was very useful as something to join together all the different elements of the arrangement. And lastly, I added the potted plant.

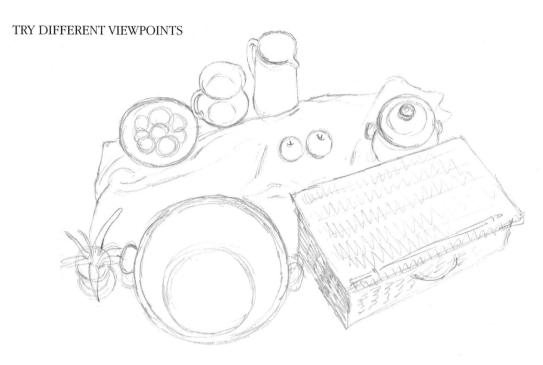

Next I laid out these objects in a loose arrangement on the floor to see what they would look like seen from a higher eye-level.

Looking down on the objects it was almost possible to draw them like a map. So did I want this high-level view?

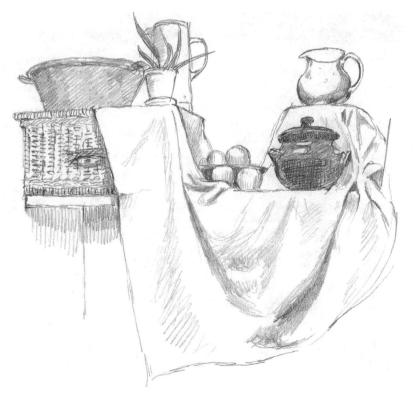

I then had to try the alternative – a low-level view where I would have to look up at all the objects to draw them. So I put them all on a table and sat down on the floor to see the effect. From this position the composition took on a monumental quality.

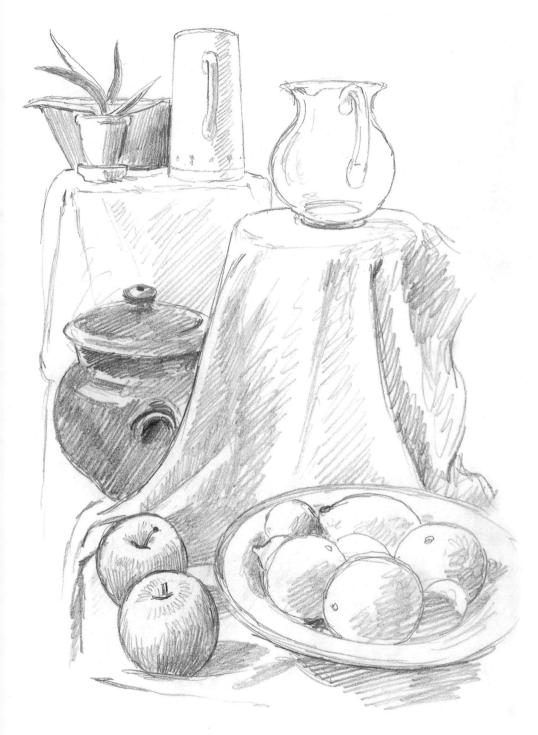

Next I rearranged the objects and walked round them until from one side I got this view of them partly at my eye-level and

partly below it, which gives an interesting effect and also draws the eye into the picture more easily.

SPREAD OUT OR CLOSE TOGETHER?

Having considered a high view, a low view and a medium view, I thought I should see if the

objects were more interesting close together or spread out.

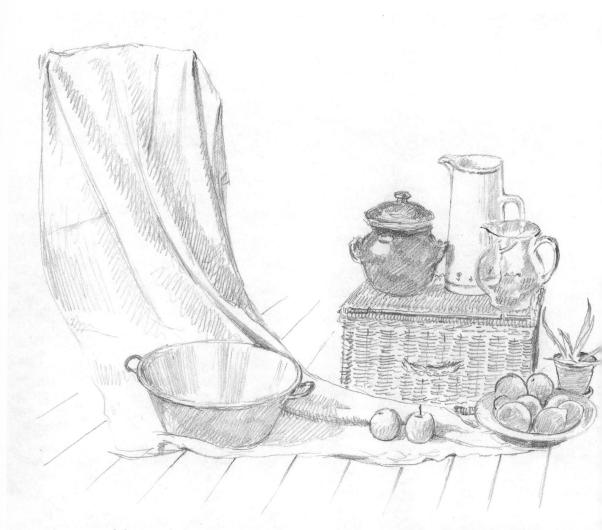

I arranged them with the cloth spread out from the back of a chair across the floor as far as it would go. I placed the copper pan on the floor on the cloth and put the bowl of fruit at the furthest end of the cloth to hold it in position. In between these two I placed two apples, and behind them the wickerwork hamper and the potted plant. On the hamper, I put the pot, the tall jug and the glass jug. The effect was of space, defined by the cloth and the objects being comfortably far apart.

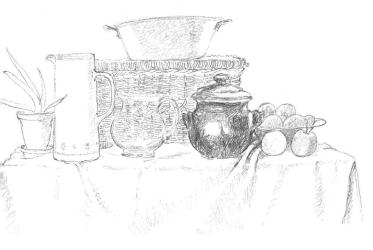

The next thing to try was to lay the cloth on a table and then place all the objects as close together as possible, which I did by putting the hamper at the back of the table with the big copper pan on top and all the other things lined up close together in front of it. I placed the two apples just in front of the bowl of fruit. This gave a very compact group and looked interesting.

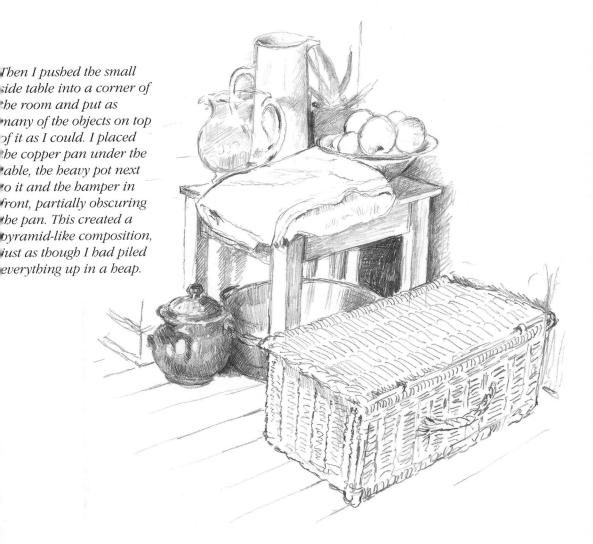

BRINGING IT ALL TOGETHER

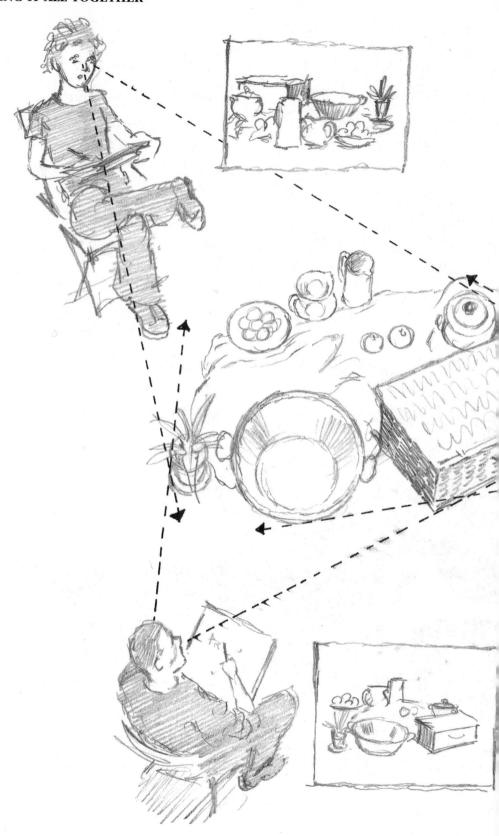

Laying out all the objects and then trying out different positions to draw them from was the next step. As you can see in the diagram, each artist in each position sees the same arrangement but gets an entirely different view and effect. When you do this yourself, move around the shapes slowly, trying to

establish which viewpoint will give you the composition that you think is the most satisfying. Not only do you move the objects around, you also move yourself around the objects to get the best view. This will change both the arrangement of the shapes and the kind of lighting.

KNOW YOUR OBJECTS

Having selected your objects, found a place to put them and made a plan for the composition, the next thing is to understand each object more thoroughly. The best possible way to do this is to draw them separately as many times as you like in order to really get to know them. This is very good practice for the final drawing.

Drape a cloth over something and observe the sort of folds that the material makes. Each kind of material should be studied; this particular cloth had soft, heavy folds with creases showing up in it.

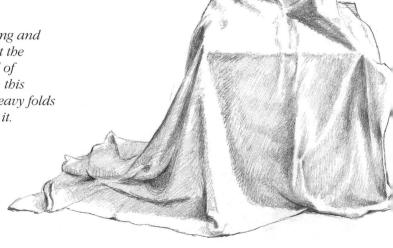

The glass jug had a quality of transparency and was highly reflective. It was not so easy to draw as the cloth, but trying it out soon gave a good idea how this object could be effective in the final still life.

I drew the plant from several views in order to get some idea how it grew. As the only living thing in my composition, it was probably the most subtle object.

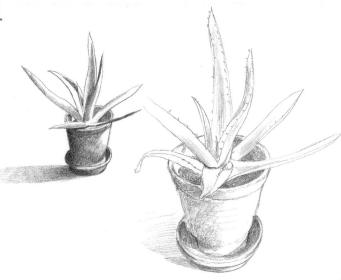

The main thing about drawing the beavy pot was to get the effect of its roundness and bulk. This required a bit of practice so that I could get the shape drawn in swift movements of my pencil without pausing.

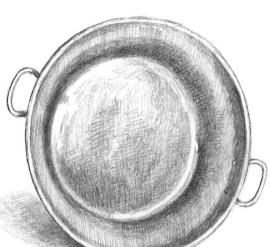

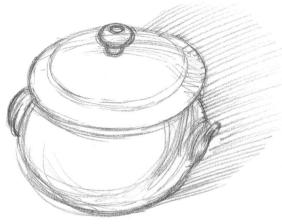

The copper pan had both reflectiveness and solidity and I decided that I would like to look into it, so it required support from behind with a stool or box so that I could see the shinier interior. The round shape also was a good, large form to place behind other things.

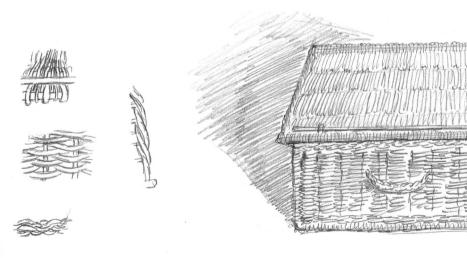

The wickerwork hamper was a nice straightforward shape, but its texture was harder to draw. I made some studies of the way that the pieces of wickerwork were interwoven, especially round the edges and the handle.

KNOW YOUR OBJECTS

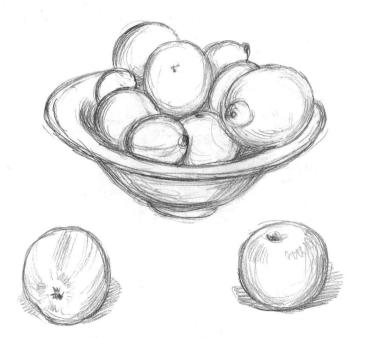

The bowl of oranges and lemons and the apples basically called for the same treatment. I drew them rapidly with unbroken lines until I had got the feel of their shapes and how they lay against each other.

I drew the tall white jug with its edge pattern from different angles until I had decided which angle suited my composition best.

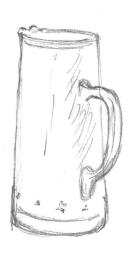

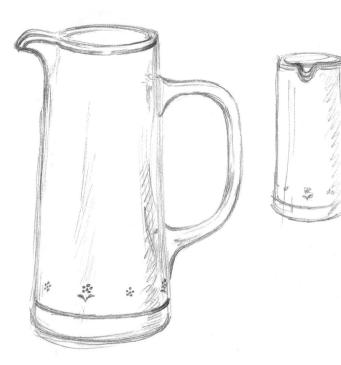

A ROUGH COMPOSITION

With everything else resolved, I had to put together my final idea for the composition of my picture. Here I have drawn a very rough composition of the arrangement of all these different objects that I decided I liked best of all. I settled upon the angle of the light and what sort of background the composition should have.

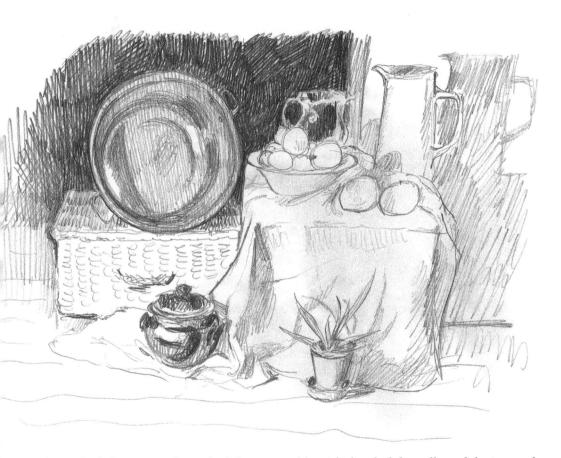

Here, I have the light coming from the left, fairly low and casting a shadow on some of the objects on the side wall. Behind the main part of the composition is the darkness of the room behind, so the arrangement is well lit but against a dark space. I covered the side

table with the cloth but allowed the jug and bowl of fruit to rumple it up a little. The heavy dark pot and the spiky plant are at the base of the foreground. The hamper and the large copper pan act like a backdrop on the left-hand side.

OUTLINE DRAWING

Having decided on my arrangement and made a fairly quick sketch of it, I now knew what I was going to do. The first thing I needed to establish was the relative positions and shapes of all the articles in the picture. so I made a very careful line drawing of the whole arrangement, with much correcting and erasing to get the accuracy I wished to convey in the final picture. You could of course use a looser kind of drawing, but for this exercise I was being very precise in getting all the shapes right and their dispositions carefully related. This is your key drawing which everything depends on, so take your time to get it right. Each time you correct your mistakes you are learning a valuable lesson about drawing.

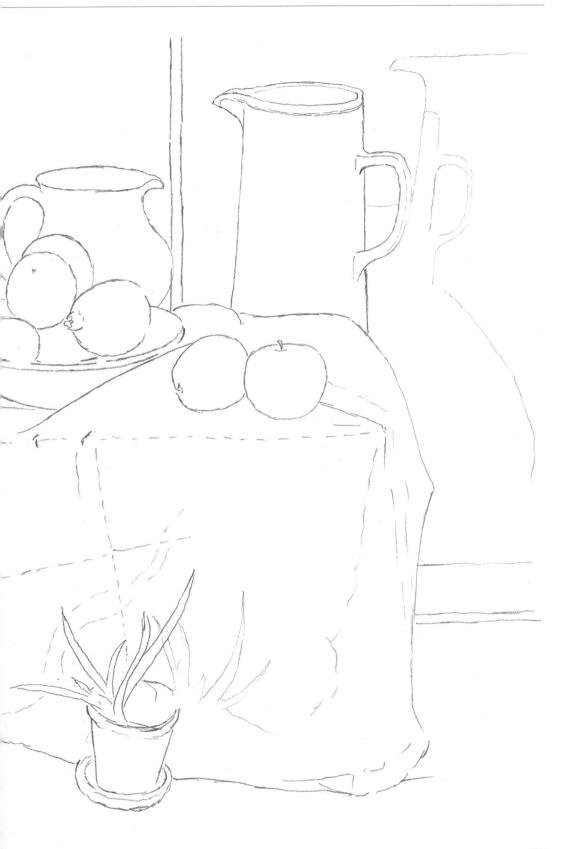

BLOCK IN THE TONE

After that I blocked in all the areas of the main shadow. Do not differentiate between very dark and lighter tones at this stage; just get everything that is in some sort of shadow covered with a simple, even tone. Once you have done this you will have to use a sheet of paper to rest your hand on to make sure you do not smudge this basic layer of tone. Take care to leave white all areas that reflect the light.

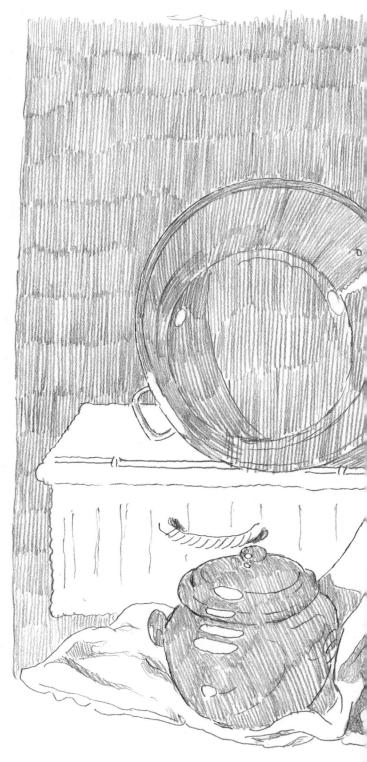

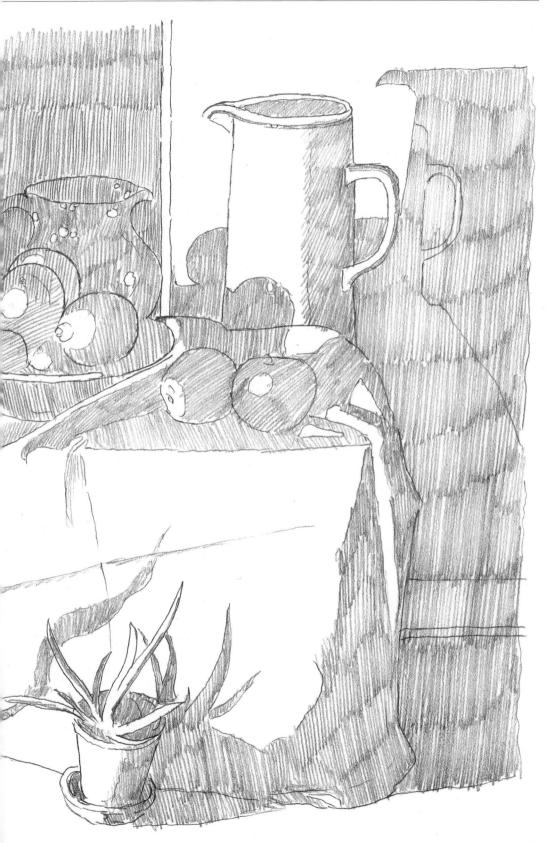

THE COMPLETED PICTURE

Finally, I did the careful working up of all the areas of tone so that they began to show all the gradations of light and shade. I made sure that the dark, spacious background was the darkest area, with the large pan, the glass jug and the fruit looming up in front it. The cast shadows of the plant and where the cloth drapes were put in crisply and the cast shadow of the jug on the side wall required some subtle drawing.

Before I considered my drawing finished, I made sure that all the lights and darks in the picture balanced out naturally so that the three-dimensional aspects of the picture were clearly shown. This produced a satisfying, well-structured arrangement of shapes with the highlights bouncing brightly off the surfaces.

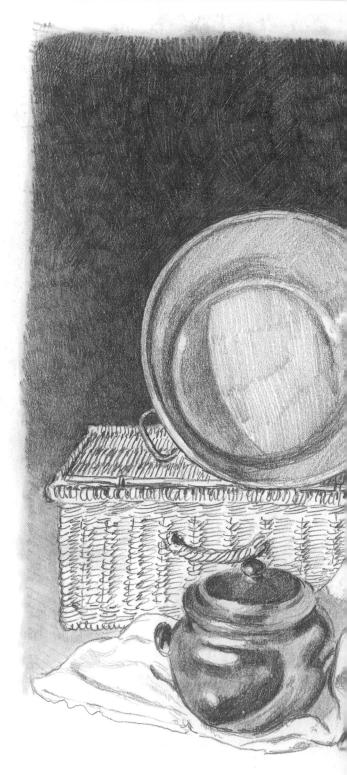

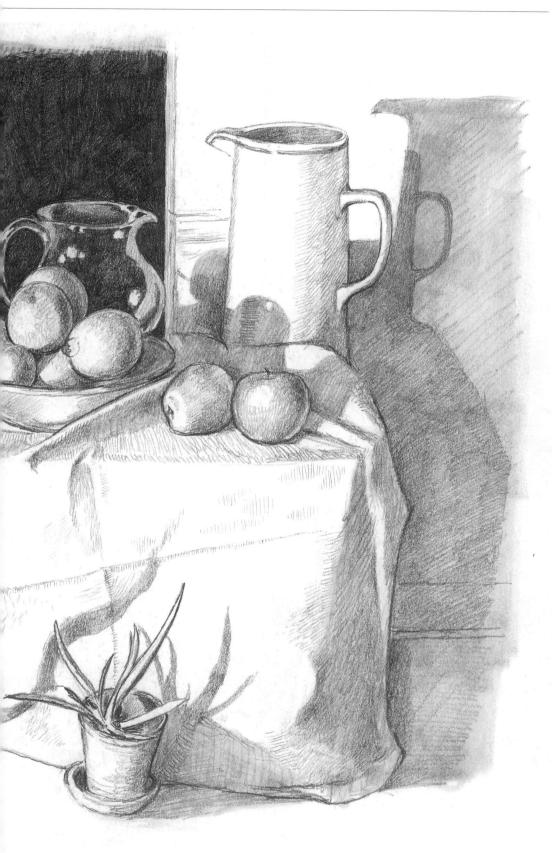

advertising, illustrations for 160	natching 127, 129, 132	Pagean Savarin 139
animals, dead 80, 170	highlights 35, 132, 133, 204, 206	Roesen, Severin 139
apertures, looking through 112-13	Hodgkin, Eliot 87, 90	Rome, ancient 160, 167
art, examples from 136-43		Rousseau, Henri 140
atmosphere 79, 118	interiors	
	looking into 120-1	saucepan 34–5
backgrounds 175, 189, 206	sense of space 112-13, 116	sea-related objects 78, 96–7, 123
bicycle 39	suggesting outside world 115, 118-20	settings, choosing 186-7
bones 52, 177		shading 14, 21, 127
books and paper 94–5	key drawing 202–3	exercises 21
bottles 23, 25		shadows 15, 26, 38, 74-5, 131, 206
brushes 10, 11, 131	lamps 38, 50	shapes, unusual 32-9
brush and wash 31, 34–5, 130–1, 138	leaves 57	shells 53
Drush and wash 31, 34–3, 130–1, 130	Leonardo da Vinci 127, 137	sketches, initial 201
122	The state of the s	snow 166
car 122	lighting 106	space
carbon pencils 10–11	artificial 74–7	creating sense of 112–13, 116
Cézanne, Paul 143	choosing 188–9	
chairs 27, 38, 106	direction of 15, 29, 50, 74–7, 201	suggesting larger spaces 114–17, 122
chalk 10, 11, 30, 31, 132–3, 140–1	effect of 78–9	spherical objects 15, 28–9
charcoal 10, 11	lines: exercises 12–13	stones 54
Chardin, Jean-Baptiste-Siméon 70, 85, 104	loose-line technique 126, 128	stump 11, 127
circles 12		style, individual 164–5
cloth 198	Magini, Carlo 84	subjects
composition 82-109	Magritte, René 179	selecting 182-3, 190-1
apparent disorder 150-1	materials	unusual 108, 166-71
choosing 201	drawing materials 10-11, 126-35	surrealism 179
unusual arrangements 106–9, 146–7, 156–79	mixing subject materials 80-1	symbolism 98–9
Conté 10	Matisse, Henri 91, 138	•
	measurements	table settings 172-3
contrast	of objects 23	tactile subjects 154–5
of texture 32, 38, 56–7, 80–1		techniques 124–35
of tones 32, 50	of picture 70–1	examples from art 136–43
Craig-Martin, Michael 164-5	media	textiles 42–5
cubes 14	choosing and using 30–1, 102–3	
cubism 179	mixed 134–5, 142–3	texture 42–5, 51
cup 30	Meléndez, Luiz 87	contrasting 32, 38, 56–7, 80–1
cylinders 17	metal 33, 34–5, 50–1, 199	solid objects 24–5
	Miró, Joan 109	themes 82–109
Dali, Salvador 99, 161	Morandi, Giorgio 100-1, 165	three-dimensional objects: exercises 14-15
depth 70, 71, 148	movement, suggesting 99, 119	tone 14–15, 49, 131
1	musical objects 93, 95	balancing 206
ellipses, drawing 16-19, 22		blocking in 204-5
erasers 11	negative shapes 68–9	contrast of 32, 50
everyday objects 152–3, 162–3		three-dimensional images 14, 15, 17
eye: leading in to picture 147, 193	outdoor subjects 114, 117, 122-3	exercises 20-1
eye. leading in to picture 147, 179	outlines, drawing 49, 127, 202	tools 36-7
F .: 1 II: 105 141	outlines, drawing 47, 127, 202	toys 56, 107
Fantin-Latour, Henri 105, 141	nonor 11	travel equipment 92
fixing 133, 141	paper 11	trompe l'oeil 71, 148, 178
flowers 57, 66–7, 104–5, 140	applying torn paper 134–5	Hompe Focii 71, 140, 170
food 58–9	as subject 46–7, 94–5	and the
food and drink 84-91	tinted 132, 133	unusual, the
footwear 78, 168–9	pastel 10, 11, 132–3	arrangements 156–79
'framing' (space around subject) 72-3	patterns 91, 109	shapes 32–9
fruit 28, 66, 130, 158-9, 177, 200	pencil 30, 102, 136	
and vegetables 175	techniques 126–7	Van Gogh, Vincent 142, 168
furniture 106	types of pencils 10	vases 24, 29, 56
	exercises 20	vegetables and fruit 175
glass 16, 22-3, 25, 31, 48-9, 171, 198	pen and ink 137	viewpoint 118, 192-3, 196-7, 200
gouache 35	pens 10, 11, 128	
graphite pencils 10, 11	techniques 30, 31, 128-9	Wadsworth, Edward 97
• •	exercises 20	wash and brush 31, 34-5, 130-1, 138
groups of objects 36–7, 62–81	perspective 26–7	watercolour 103
combining 60–7, 194–5		whites 132, 204
drawing objects separately 198–9	plants 128, 198	wickerwork 27, 38, 182
encompassed groups 66–7	portraits from objects 176	wood 55
how many objects? 146–7	proportions 23	
Guttoso, Renato 86	1 1 2 2 7	Wyeth, Andrew 79, 119–20
	rectangular objects 26–7	
Hamen y Leon, Juan Van der 88-9	reflections 24, 28, 29, 32, 33, 50, 122	

Hamen y Leon, Juan Van der 88-9